art maps

# How to Paint Watercolors That Shine!

## by William C. Wright

international
artist

International Artist Publishing, Inc
2775 Old Highway 40
P.O. Box 1450
Verdi, Nevada 89439

Edited by Jennifer King
Design by Vincent Miller
Typesetting by Nicolas Vitori and Cara Herald

ISBN 1-929834-47-0

Printed in Hong Kong
First printed in hardcover 2004
08 07 06 05 04  6 5 4 3 2 1

Distributed to the trade and art markets in North America by:
North Light Books,
an imprint of F&W Publications, Inc.
4700 East Galbraith Road
Cincinnati, OH 45236
(800) 289-0963

## Copyright warning!

# Contents

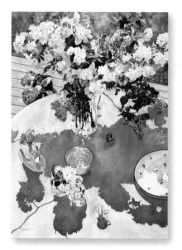
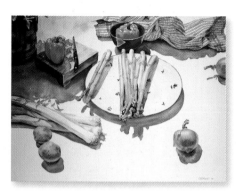
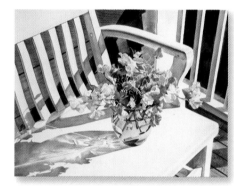
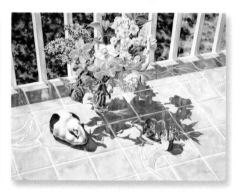

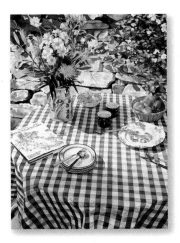
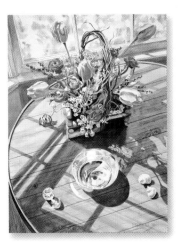
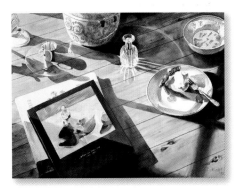
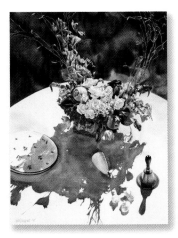
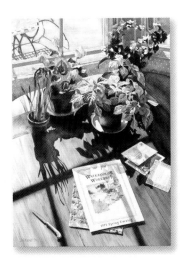
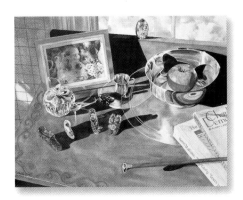
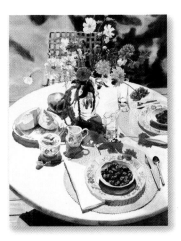

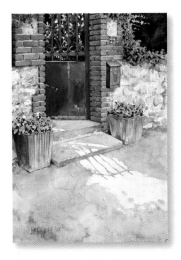

# About the artist

William C. Wright has been a professional painter for more than 25 years. An accomplished watercolorist, his realistic style is noted for its dramatic light and color. He works in the traditional watercolor method of layering transparent washes on paper, building from light to dark.

Bill's work has been shown in many galleries throughout the US, as well as in many national competitions. Most notably, his work has appeared in the American Watercolor Society's annual exhibition (New York, New York) and in Watercolor USA's annual exhibition (Springfield, Missouri). As a signature member of the American Watercolor Society, the Baltimore Watercolor Society and the Mid-Atlantic Plein Air Painters Association, Bill regularly exhibits in these groups' shows.

He is represented by Leslie Levy Fine Arts, Scottsdale, Arizona, and by Munson Gallery, Chatham, Massachusetts. He lives with his wife and family outside Baltimore, Maryland, where he maintains an active painting and teaching career.

Although Bill's work has appeared in 11 books and magazines — including *International Artist*, when he won First Prize in the 2003 Still Life and Floral Art Prize Challenge — this is the first time he has authored a book.

# Introduction

**W**atercolor is a wonderful medium with characteristics that are completely unique. Those of us who use watercolor frequently, and especially those of us who've tried other painting media, agree that watercolor's materials, techniques and final results are irresistibly attractive. Working on paper with pencil and paint just feels right! So if you've picked up this book, you either have the same inclinations and know what I mean, or you're about to discover something fantastic.

## What you're about to learn

If you're like me, you want to understand how to create paintings that shine, that stand out in a crowd, that grab a viewer's attention and refuse to let go. My secret to creating paintings with this kind of impact is **contrast** — using opposites to attract the eye. There are many types of contrast available to an artist. Some of my favorite pairs are warm and cool colors, organic and geometric shapes, hard and soft edges and light and dark values. I'll pinpoint and explain how I've used all of these contrasts as you work through these 15 Art Map projects so that you can learn to put them into your own work when you're ready.

Another design concept I use to create watercolors that stand out is **lighting**. My still lifes are usually lit with a direct light from behind, which is called *backlighting*. This type of light provides strong cast shadows that fall in front of the objects, adding to the visual interest of the painting. In fact, my paintings are frequently more about the deep shadow and the reflected light bouncing around in it than the objects themselves. As you recreate these paintings, you'll begin to understand how you can strengthen your designs by paying attention to light and shadow.

Many people are attracted to my paintings because of their **realism**. They feel as if they could reach out and touch these objects. I use many techniques to make my paintings look convincingly real — which I'll explain to you as we go along — but perhaps the most important of these is good **drawing** skill. Your ability to draw is particularly tested when working with watercolor because there is little opportunity to make corrections after you begin to paint.

However, I've made this aspect of the process much, much easier for you by providing a simplified drawing for each project, complete with a grid that you can use to transfer the image onto your watercolor paper. This will give you invaluable drawing practice and will ensure you get the whole image onto your paper and positioned in the proper place so that the design works. That's why we call them Art Maps. They're your guide to getting to your destination — beautiful watercolor paintings.

# How my methods work

Before we get started, I thought I should take a moment to explain my general approach to painting, especially some of the behind-the-scenes stages that are not covered in this book. My hope is that these steps will help you develop a consistent approach to painting that you can use to create your own masterpieces later on.

Using actual objects that interest me, as well as a strong light usually positioned from behind, I begin by developing a still life arrangement that involves one or more kinds of contrast. I then photograph my arrangements to preserve them, although I use these photos only as a starting point for my final concept. I am not a slave to the photographs, and I often later change the colors and reposition or alter the objects to suit the needs of the painting.

Even though I use photographic reference material, I believe that painting from life is equally important. We should all continue to practice this skill. This is why I always keep the objects in the studio with me as I work so that I can check the accuracy of scale, color and fine details. Photographs can distort these qualities in your still life, so it's best to work from life as much as possible.

I then spend days, even weeks, perfecting my drawings before I lay down a single stroke of paint. I always draw on a separate sheet of good-quality drawing paper where I can work out my design and do careful rendering, which may require plenty of erasing until I get it just right. Watercolor paper can't handle this kind of abuse, which is why I always work out my drawings separately and then transfer them to the painting's surface.

To transfer, I lay a sheet of heavy tracing paper over the drawing and trace it in pencil. I then cover the back of the tracing paper with graphite. Finally, I lay the tracing paper over a clean sheet of watercolor paper. When I go over the lines of the drawing with a pencil, the graphite on the back transfers to the watercolor paper, leaving a clean, light pencil drawing.

When it comes to painting, I use the traditional watercolor method, which is to work from light to dark and paint around the lightest lights, leaving the paper white. Specifically, I start developing a painting with light values and soft edges, gradually making gentle transitions from light to dark.

To rise to the challenge of painting realistically, I've adopted a unique approach to painting that offers a lot of control. I work very slowly, using two relatively small, round brushes at once. I load one paintbrush with pigment and the other slightly larger brush with clean water. To paint an area, I begin by wetting with clean water and then lay in the paint before the water dries — a wet-into-wet technique. I paint small areas, one at a time, and let each layer dry before adding more.

If you want to paint like me, you'll have to learn to slow down, be patient and let areas dry. Don't rush — enjoy the process and wait for the fantastic results to emerge. The watch word here is perseverance.

# Materials you will need to paint every project in this book

Over time, you will surely discover your personal color preferences and set up your palette in your own special way. This is part of developing your style and finding a look that distinguishes you from other artists. In the meantime, however, you can use my palette colors listed for each project.

Because I've been mixing these same colors for many years, I now know exactly what to expect from certain combinations. And as you progress through the Art Map projects, I'll teach you some of my favorite color mixes that you can use in your own work. In particular, I'll show you several ways to mix beautiful grays, which you're going to need. Remember the concept of contrast? You'll soon understand that you need some neutral colors in order to make your bright hues stand out.

If you're going to keep this many colors on hand, you will need a very large plastic palette with plenty of wells for holding the pigments. I also recommend purchasing some porcelain dishes to use when mixing up large quantities of paint.

As for paper, I recommend a bright white, 140lb (300gsm) hot-pressed paper for smaller works. Before you begin painting, stretch this paper by soaking it in clean water and tacking it to a board, then letting it dry. This will allow it to soak up a lot of water and paint without buckling. The smooth surface means you'll get crisp edges and bright color. For larger paintings, I suggest using a 300lb (638gsm) cold-pressed paper, which can absorb a lot of water even without being pre-stretched. Whatever you choose, be sure to buy a high-quality, pH-balanced paper. Good, durable paper is well worth the extra expense.

For this type of controlled work, you will only need a selection of smaller sable rounds, mostly sizes 3, 4 and 5. You may want to buy a few smaller brushes, going down to a No. 1, but you won't need anything larger than a No. 8. Don't be fooled by price — I have had very good performance from less expensive sable brushes, and I encourage you to practice with these.

### Colors you will need

| | |
|---|---|
| Alizarin Crimson | Cadmium Lemon |
| Cadmium Red Deep | Sap Green |
| Aureolin | Phthalo Green |
| Cerulean Blue | Chinese White |
| Opera (or Magenta) | Hooker's Green Dark |
| Phthalo Violet | Cadmium Yellow Deep |
| Ultramarine Blue | Naples Yellow |
| Burnt Sienna | Prussian Blue |
| Raw Sienna | Cadmium Red Deep |
| Vermilion (or Bright Red) | Oxide of Chromium |

# Time to get started

I've been teaching for many years, and I never tire of watching my fellow artists develop skills and experience the joy of learning to paint in watercolor. That's why I'm delighted to bring you this book. I know you're going to be thrilled with the results of each effort, and I'm confident that each Art Map project will further enhance your abilities to create your own watercolor paintings that shine!

# art map 1
## Sparkling spring colors

Before you begin, read the entire project through so you know what's going to happen next.

Like most people, I thoroughly enjoy the spring season. That's what this painting is all about — the glory of spring-blooming flowers and their bright, clear, cool colors. To me, this very exciting, refreshing image conjures up all sorts of wonderful feelings associated with renewal and fresh beginnings.

At first, it may appear rather complex, but don't be intimidated. I'm going to deconstruct this painting for you so that you understand it thoroughly before you attempt to recreate it. In particular, I'll show you how shapes unite the foreground with the background. Then I'll explain how to see the values accurately and how to mix all of the fresh, transparent colors found throughout the painting.

Begin by using the grid to transfer the image so your drawing is correct. Then use my two-brush method of working wet-into-wet to slowly and carefully develop this image. Be patient and persevere. You're bound to love the end results.

### 1. The image to be transferred using the art map

Read the instructions to see how to map this image across to your paper.

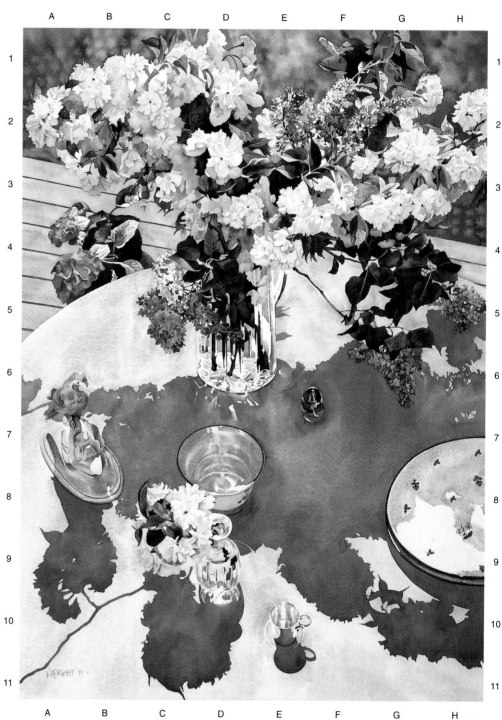

## 2. Map the image

First, study how this painting has been divided into a grid. The painting's grid has been evenly divided into 11 horizontal rows and 8 vertical columns. Notice how the grid has been referenced with numbers and letters — just like a map. My painting was 29 x 21" (74 x 54cm), but I recommend using a smaller sheet that is the same proportion as the original painting. Otherwise, it will take you a month to put in the details!

## 3. Use the art map to transfer the image

Now make a corresponding grid on your watercolor paper. Letter and number the grid, using a HB pencil and drawing very lightly. Next, start copying the drawing box by box, referring to the grid reference letters and numbers as needed. Hint: Start by positioning the main shapes first, such as the bouquet, the cast shadow and the other objects on the table. Then lightly add the rest. You don't have to draw every single detail — just get the main shapes down.

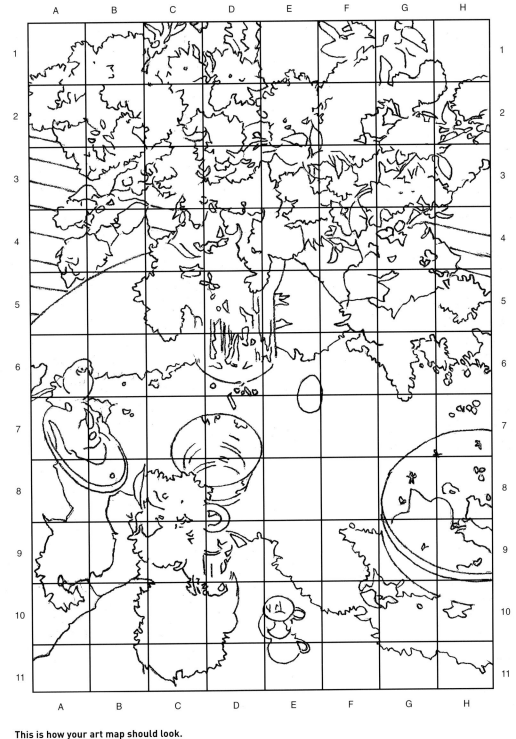

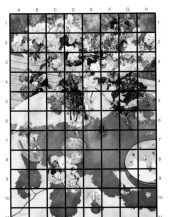

**By using this method, you can enlarge or reduce the image to any size you want.**

**This is how your art map should look.**

Here I've done the drawing quite heavily so you can see the idea, but you will do this lightly in pencil.

# Study these pages before you start painting

**Shape map**
Notice how the curved shape of the table reaches under the bouquet, while its cast shadow shape connects all of the foreground objects. The overlapping shapes in this image unite the top half with the bottom half.

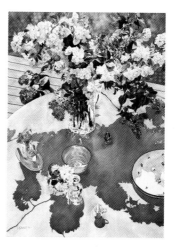

**Tonal value map**
Shown in black-and-white, you can see how much of the painting is devoted to lighter values. You can also see the darkest values sprinkled throughout the background and bouquet. The large area of mid-value shadow provide a transition between the two.

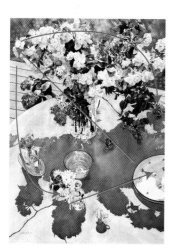

**Movement map**
Because of the strategic placement of points of tonal contrast, as well as some distinctly diagonal lines, your eye tends to zigzag up and down, never leaving the painting.

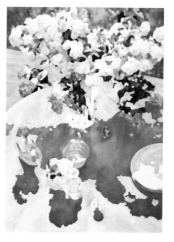

**Color map (squint)**
One of the most striking features of this image is the clear, bright color. Blue definitely dominates, and hints of blue and blue-violet appearing in other areas, such as flowers and foliage, help to unify the image.

## materials you'll need

**paper**
140lb (300gsm) hot-pressed or
300lb (638gsm) cold-pressed

**brushes**
nos. 1 through 8 sable rounds

**other tools**
HB pencil
gum eraser
ruler
paper towels
test scrap of same watercolor paper

## your palette for this painting

Aureolin                          Vermilion or Bright Red

Cadmium Lemon                     Cadmium Red Deep

Cadmium Yellow Deep               Alizarin Crimson

Naples Yellow                     Opera or Magenta

Raw Sienna                        Phthalo Violet

Burnt Sienna                      Sap Green

Cerulean Blue                     Hookers Green Dark

Ultramarine Blue                  Oxide of Chromium

Prussian Blue                     Chinese White

# Consider the following elements

## Light source

Here, the backlighting coming from directly behind the vase of flowers creates a large cast shadow that connects all of the smaller, supporting objects. Note the shapes and consistent direction of the other cast shadows.

## Viewpoint

Looking down from above allowed me to highlight the repeating circles of the table and objects and to include the strong diagonal in the background.

## Bright idea

When mixing a particular color, such as pink, mix several variations of the color right next to each other on your palette or porcelain dish. For example, mix up a light pink, a dark pink and a cool blue-violet. This way, you'll be ready to quickly and easily change value or color as you develop each small section.

## Beware

Masking fluid can ruin a good brush, plus I don't think it's much of a time-saver. I recommend using small brushes and simply painting carefully around the whites.

## 4. Start with the lights

You've got a lot of flowers to paint, so mix up large quantities of each of the three pinks shown. Go slowly, applying clear water to each area, then laying in the correct pinks wet-into-wet for each petal. Work around the whites, and remember to add touches of blue to the fronts of the flowers that are in shadow. Don't miss the small cluster of flowers in the foreground.

**Chinese White + Alizarin Crimson**     **Chinese White + Opera**

**Pink mixture + Cerulean Blue**

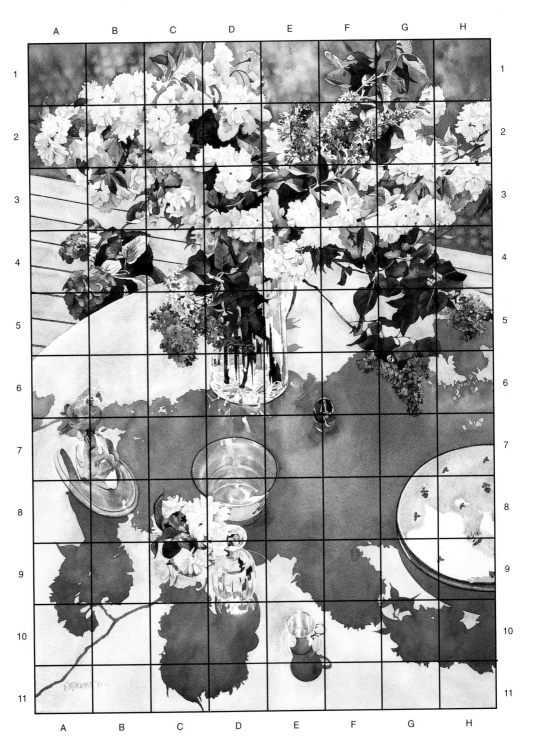

# Put it all together

## 5. Drop in the background

When the flowers are completely dry, add the green foliage behind them. Work slowly as you apply the clear water along the edges of the flowers. Then drop in both warm and cool combinations of darker greens, and tilt your board to make the colors merge wet-into-wet. Use more pigment and less water on these greens to keep them fairly dark. If your first attempt isn't dark enough, let it dry and glaze on a second coat.

**Cadmium Lemon +
Cerulean Blue**

**Cerulean Blue +
Cadmium Lemon**

**Hookers Green +
Ultramarine**

## 8. Paint the objects

Using smaller brushes, go in and paint each of the objects, modeling them according to the values and colors I've used. Various combinations of Cerulean, Vermilion and Raw Sienna are perfect for the shadowed sides of the objects.

## 9. Define the cast shadow

This large shape is one of the most important features of this painting. Study it closely before you begin, especially where it does and does not fall in relation to the objects. Note the wonderfully ragged edges and the variations of color within the large shape. When you're ready, mix up several, very large combinations of Cerulean, Ultramarine Blue, Vermilion and Burnt Sienna, some slightly darker and some slightly lighter. Now begin to lay down the clear water, then pull from the different paint mixes as you go along for variation.

**Cerulean Blue +
more Vermilion**

**Cerulean +
Vermilion +
Raw Sienna**

## 6. Lay in the deck

Using a warm, lighter value mixture of Raw Sienna with touches of Cerulean and Vermilion, paint in the entire deck area wet-into-wet. By slightly changing the amount of water you put down, as well as the pigments, you can create subtle variations that will suggest wood.

## 7. Cover the tabletop

Now you'll need to mix up a very large batch of Cerulean Blue tinged with some Vermilion. Put the clear water down first, then lay down the paint mixture. Carefully work around the crystal vase and other objects on the table.

**Cerulean Blue +
Vermilion**

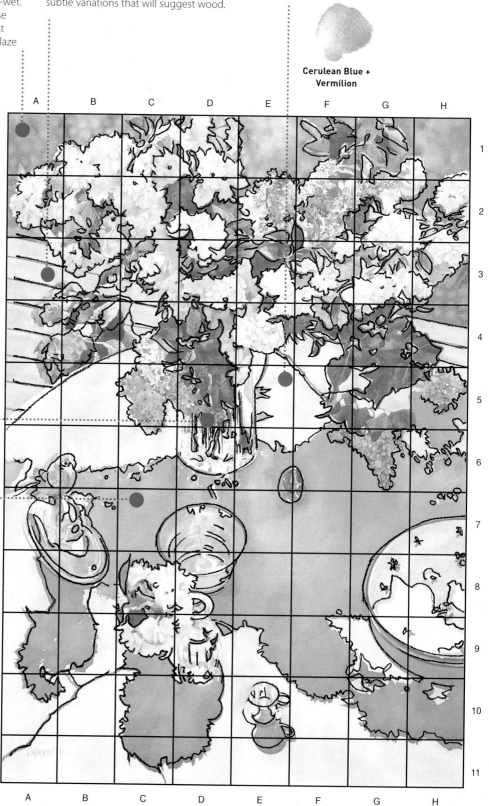

## 10. Put in the green leaves

Using darker versions of the same greens you used in the background, put in the leaves and stems of the bouquet. Because you have all of your other values established, you will quickly be able to tell if your leaves are dark enough. If not, wait until they're dry, then glaze on more layers.

## 11. Finish with details

When everything is dry, use smaller brushes to add the darker details wet-on-dry, including the lines in the deck, the places in the crystal vase that reflect the blue from the tabletop and the flowers inside the bowl. You can adjust any colors or darken values by adding glazes if needed.

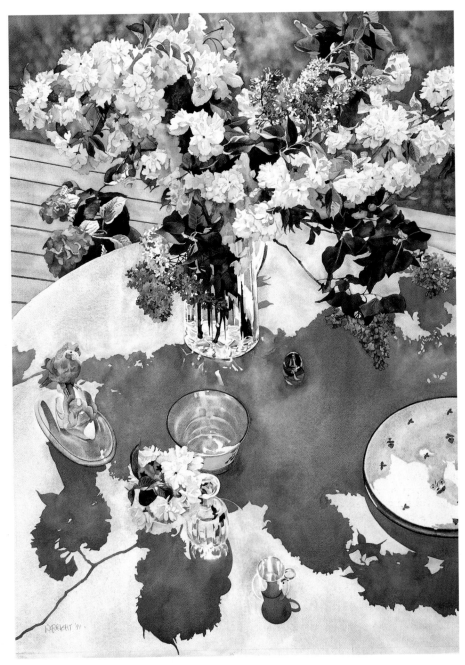

**Detail**

*Under the Cherry and Lilac II*, watercolor, 29 x 21" (74 x 54cm) by William C. Wright ©

**Detail**

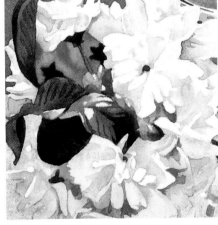

**Detail**

**Detail**

11

# art map 2
## The power of white

Before you begin, read the entire project through so you know what's going to happen next.

Initially, I set up this still life arrangement for my students, but I was so pleased with the results that I just had to paint it for myself. I was fascinated by the connections among the objects and their shadows, plus it has a multitude of contrasts that make it even more appealing.

Perhaps the most obvious element in this painting is all that white space. The paper itself provides a wonderful foil for the bright and intense colors sprinkled throughout. When choosing my objects, I made sure to offset the warm-colored objects with cool shadows, and I played the greens against their red complements. Other types of contrast, as in the tonal values and shapes, offer more opportunities for visual excitement.

So get out your materials, dole out some fresh, clean pigments and let's get to work. As always, take it slow and enjoy the process.

### 1. The image to be transferred using the art map.

Read the instructions to see how to map this image across to your paper.

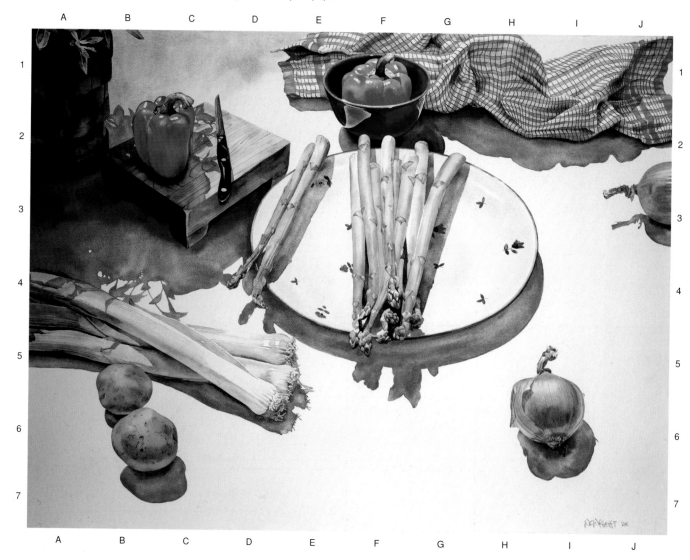

## 2. Map the image

First, study how this painting has been divided into a grid. The painting's grid has been evenly divided into 7 horizontal rows and 10 vertical columns. Notice how the grid has been referenced with numbers and letters — just like a map. My painting was 22 x 30" (56 x 76cm), but I recommend a smaller sheet in the same proportion as the original painting.

## 3. Use the art map to transfer the image

Now make a corresponding grid on your watercolor paper. Letter and number the grid, using a HB pencil and drawing very lightly. Next, start copying the drawing box by box, referring to the grid reference letters and numbers as needed. Hint: Start by positioning the main shapes first, then lightly add the rest. You don't have to draw every single detail — just get the main shapes down.

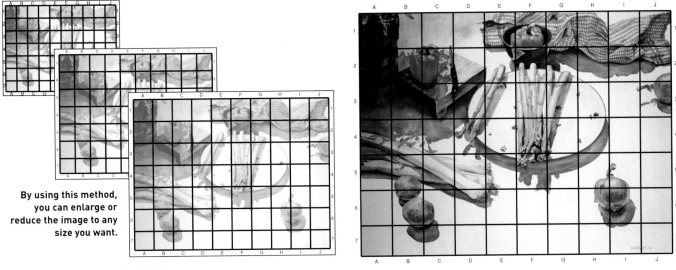

**By using this method, you can enlarge or reduce the image to any size you want.**

**This is how your art map should look.**

Here I've done the drawing quite heavily so you can see the idea, but you will do this lightly in pencil.

# Study these pages before you start painting

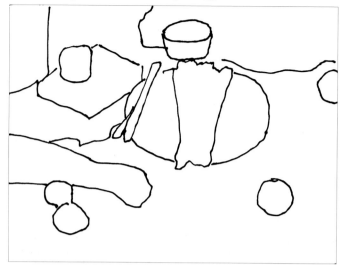

**Shape map**
Look at the contrasts in these shapes — large and small, round and rectangular, vertical and horizontal. Together, they give the viewer's eye plenty to explore and enjoy.

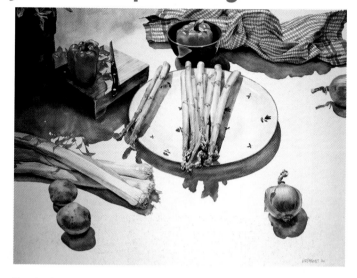

**Tonal value map**
Looking at the painting in black-and-white, you can see just how dark these shadows are. This is an extreme value contrast — everything from stark white to near-black. What impact!

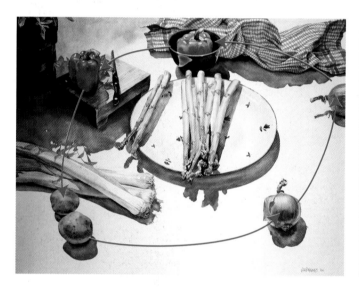

**Movement map**
Conduct a little experiment here. Cover up any one of the round objects with your finger and pretend it's not there. Would the design still be able to guide your eye in a circular pattern? It's a great a lesson in the power of even one small, well-placed object.

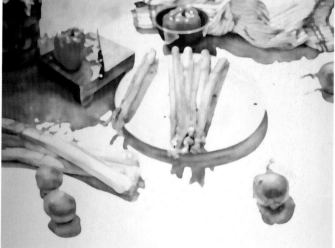

**Color map (squint)**
Look for the reds and greens, then look for the blues and oranges. Whenever complementary colors (two colors that lie opposite each other on the color wheel) appear together, they make each other stand out.

## materials you'll need

**paper**
140lb (300gsm) hot-pressed or
300lb (638gsm) cold-pressed

**brushes**
nos. 1 through 8 sable rounds

**other tools**
HB pencil

gum eraser

ruler

paper towels

test scrap of same watercolor paper

## your palette for this painting

Aureolin
Cadmium Lemon
Cadmium Yellow Deep
Naples Yellow
Raw Sienna
Burnt Sienna
Cerulean Blue
Ultramarine Blue
Prussian Blue

Vermilion or Bright Red
Cadmium Red Deep
Alizarin Crimson
Opera or Magenta
Phthalo Violet
Sap Green
Hookers Green Dark
Oxide of Chromium
Chinese White

# Consider the following elements

## Light source

The light from the back left is quite strong here. Very intense light tends to bleach color out of objects, leaving stark white surfaces. It also casts rich, dark shadows.

## Viewpoint

Notice how I positioned most of the objects toward the upper left, leaving the rest of the page fairly empty. The open areas provide visual balance to the busy areas of bright color.

## Bright idea

When you're setting up a still life, position your light source and turn it on as you work. With the light source present, you'll be able to see the cast shadows. Think of them as another element to work with and position the objects so that their shadows help tie the shapes of the painting together, as they do here.

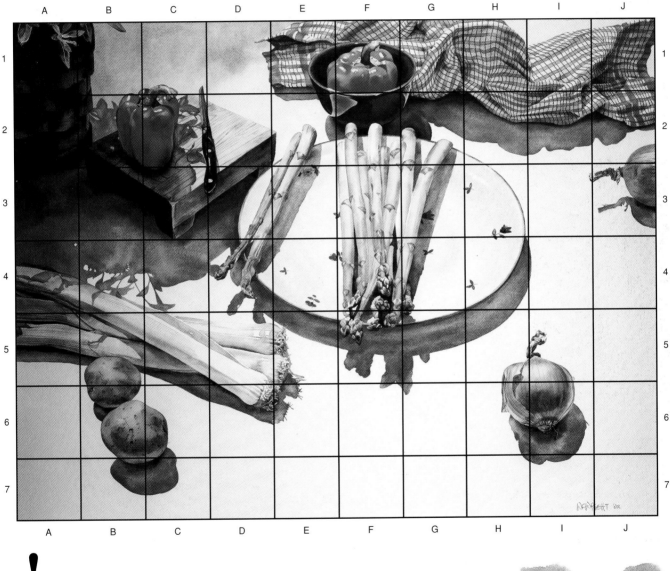

## Beware

It's not easy to nail down those rich, dark shadows in a single application of paint. If you have trouble with darks, let the first layer dry and then glaze on another layer. Repeat until you're satisfied with the results.

## 4. Start with the lights

When painting with watercolor, always start with your lightest areas first, which in this case are the leeks. Use a light blue-gray mixture of Cerulean Blue and Vermilion, and blend it up the stalks, gradually transitioning wet-into-wet to light green. Let this dry before adding Oxide of Chromium mixed with either Cadmium Lemon or Cerulean Blue.

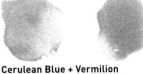

**Cerulean Blue + Vermilion**

**Oxide of Chromium**

**Cerulean Blue + Cadmium Lemon**

**Cadmium Lemon + hint of Cerulean**

# Put it all together

## 5. Switch to warm greens

The plate requires an extremely pale wash of Cerulean Blue, which you'll need to apply by working around the highlights. When completely dry, use combinations of warmer yellows, blues and Sap Green to put in the asparagus, adding Phthalo Violet for the tips and flat leaves. Let dry thoroughly before continuing.

## 6. Cast shadows on the table

Start with wet-on-dry washes of Cerulean Blue for all shadows, and let them dry. Then, working wet-into-wet, layer on Cerulean Blue and Ultramarine, adding Burnt Sienna and more Ultramarine as you get in close to the objects. Cast shadows are always darkest right next to the objects. Work one small area at a time so you can maintain control. Let dry thoroughly before continuing.

## 7. See red

Before you apply bright color to the dish towel, use Cerulean Blue — alone and mixed with Vermilion — to define the lighter shadows. Use Burnt Sienna and Ultramarine for the dark shadows. When dry, use a light wash of Cadmium Red Deep to carefully go over the stripes. Later, add Alizarin Crimson to the Cadmium Red Deep to intensify some stripes.

## 8. Put in the warm neutrals

For the cutting board, onions and potatoes, use various combinations of Raw Sienna, Burnt Sienna and Ultramarine. A touch of Cerulean will dull the color down for the potatoes, while a touch of Vermilion will warm up the onions. When dry, add glazes of Cerulean on the shadowed sides as needed to make the objects look three-dimensional.

## 9. Continue with brights

For the orange pepper in the light, use a base coat of Cadmium Orange, then add Cadmium Red Deep, Burnt Sienna and a touch of Alizarin Crimson for the shadowed sides. Use the same colors for the darker red pepper in shadow, adding Ultramarine in the darkest areas. The stems are darker versions of the green and violet asparagus colors.

## 10. Add the blue bowl

Shiny surfaces, such as this blue bowl, pick up or reflect colors from nearby objects. To paint the blue bowl, use Ultramarine as a base, moving to lighter Cerulean for the reflection of the white plate and Alizarin Crimson wherever you see reds reflected into the bowl's surface.

## 11. Layer on the darkest darks

Use various combinations of your darkest warm colors, such as Ultramarine and Burnt Sienna, to put in the basket and plant in the upper left corner. Even if you use little water and plenty of pigment, you probably won't get dark enough in your first pass. Compare your painting to the tonal map, and add thin layers of color — allowing them to dry in between — to build up these darks.

## 12. Complete the details

When everything is thoroughly dry, use small brushes to add the final details, such as the paring knife, the flowers on the plate and all of the little marks on the vegetables. Add glazes if needed to adjust any colors or darken any values.

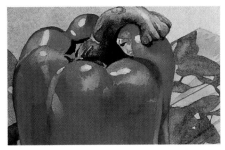

**Detail**

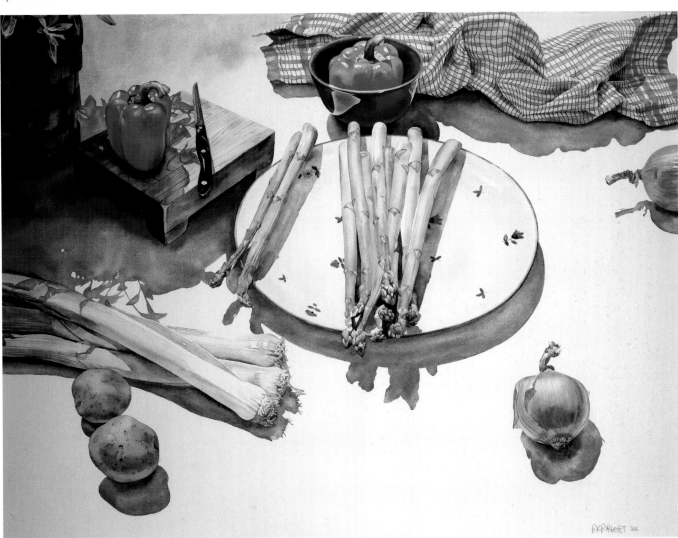

*Asparagus and Leek Soup*, watercolor, 22 x 30" (56 x 76cm) by William C. Wright ©

**Detail**

**Detail**

**Detail**

# art map 3
## Dazzling checks

I have to admit that this is one of my most complicated paintings, but I just love it! There is such a diverse range of shapes and edges, and blue and orange always make an unforgettable color combination. And, of course, there's that checked tablecloth — what a showstopper!

The most difficult part of painting such a complex subject is the drawing. Everything has to stay in perspective or the whole thing will be a disaster. Fortunately, I've taken care of this challenge by providing you with a gridded drawing. Stick to it carefully to keep your lines and edges in all the right places.

If you want, you can take a few liberties with some areas as you paint, such as the rock wall or the flowers. You might want to simplify these elements to make things a little easier on yourself. However, you'll want to retain the exact drawing and placement when it comes to the cups, plates and especially the tablecloth. Accurate handling of these objects is essential to maintain the sense of realism.

Before you begin, read the entire project through so you know what's going to happen next.

### 1. The image to be transferred using the art map

Read the instructions to see how to map this image across to your paper.

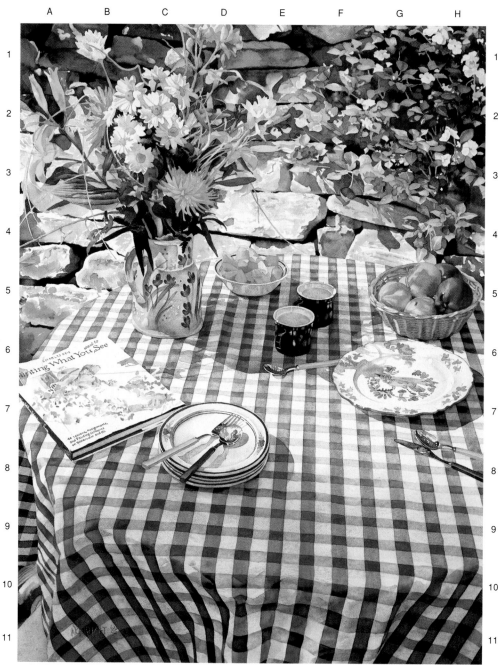

## 2. Mapping the image

First, study how this painting has been divided into a grid. The painting's grid has been evenly divided into 11 horizontal rows and 8 vertical columns. Notice how the grid has been referenced with numbers and letters — just like a map. My painting was 29 x 21" (74 x 54cm), but you may want to use a proportionally smaller size.

## 3. Use the art map to transfer the image

Now make a corresponding grid on your watercolor paper. Letter and number the grid, using a HB pencil and drawing very lightly. Next, start copying the drawing box by box, referring to the grid reference letters and numbers as needed. Hint: Start by positioning the main shapes first, then lightly add the rest. You don't have to draw every single detail — just get the main shapes down.

**By using this method, you can enlarge or reduce the image to any size you want.**

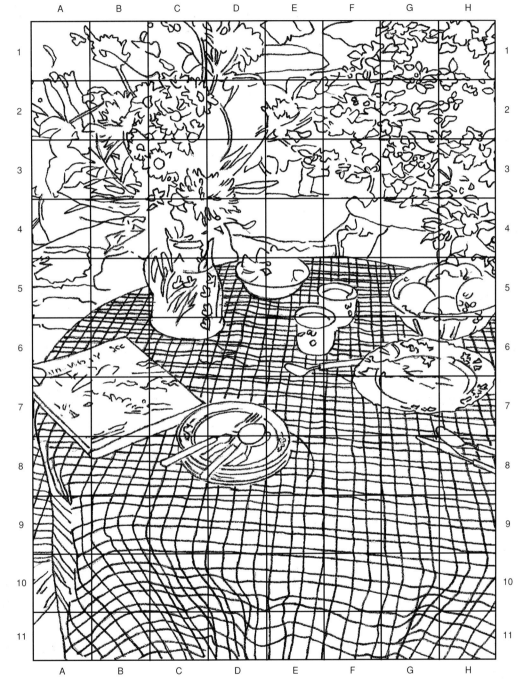

**This is how your drawing of the Art Map should look.**

Here I've done the drawing quite heavily so you can see the idea, but you will do this lightly in pencil.

# Study these pages before you start painting

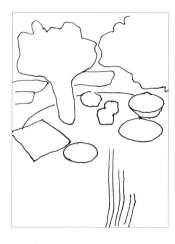

**Shape map**
Variety and contrast, as I've written, are very important. Study these shapes carefully to see how I've included verticals and horizontals, as well as geometric and organic shapes. The cast shadows provide some diagonals, too.

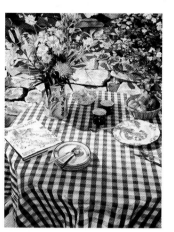

**Tonal value map**
If you concentrate on just the tonal values, you'll see how they fall into horizontal bands, starting with dark values across the top, then light, dark, light and finally dark again, creating a frame for the painting's interior. Keep this in mind as you build up the colors with glazes in the painting.

**Movement map**
The lighter values play a key role in drawing your eye into this painting. Notice how the white book cover provides an entry point on the left, while the bright light falling between the two plates on the right offers an alternate line of entry.

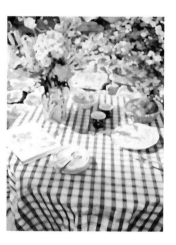

**Color map (squint)**
I love the interplay between the crisp white, the warm yellows and oranges and the cool blues and blue-greens. The combination makes the colors pop.

## materials you'll need

**paper**
140lb (300gsm) hot-pressed or 300lb (638gsm) cold-pressed

**brushes**
nos. 1 through 8 sable rounds

**other tools**
HB pencil
gum eraser
ruler
paper towels
test scrap of same watercolor paper

## your palette for this painting

Aureolin
Cadmium Lemon
Cadmium Yellow Deep
Naples Yellow
Raw Sienna
Burnt Sienna
Cerulean Blue
Ultramarine Blue
Prussian Blue

Vermilion or Bright Red
Cadmium Red Deep
Alizarin Crimson
Opera or Magenta
Phthalo Violet
Sap Green
Hookers Green Dark
Oxide of Chromium
Chinese White

# Consider the following elements

## Light source

This painting deviates from my usual in that the light comes from the left side, a little toward the back. Note how this affects the angles of the cast shadows and the placement of the highlights.

## Viewpoint

By positioning myself at this end of the table, I was able to use the perspective lines of the checked tablecloth to guide your eye up into the flowers, wall and other objects.

## Bright idea

If the object you're painting has a complex pattern or textured surface, don't try to paint it in one pass. Apply a base color first and let it dry. Then glaze on more of the same color or mixtures of colors to intensify the pattern or texture.

## ! Beware

Trying to apply a glaze to an area that's still wet will result in bleeding colors and fuzzy edges. If you want clean color and distinct edges, wait until the first layer is thoroughly dry before glazing on another layer.

## 4. Underpaint the tablecloth

Using a light wash of Cerulean Blue mixed with Ultramarine Blue, indicate the checked pattern of the cloth. Now study the shifts in the white areas from bright white at the far end to light blue in the cast shadow, then back to bright white in the center, and finally to lighter blue in the foreground and where the cloth falls beyond the edges of the table. Lay in light, wet-into-wet washes of the blue mix to begin defining the shadowed areas. Remember, this is just an underpainting; you'll come back and refine this area later.

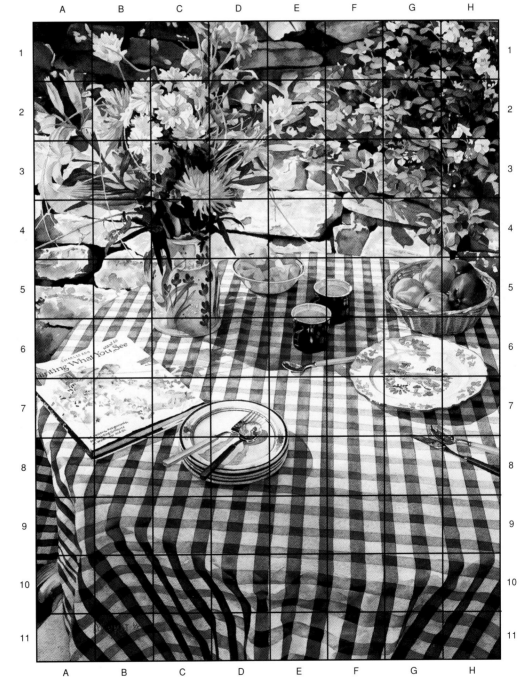

# Put it all together

## 5. Start the stone wall

Use a mixture of Ultramarine Blue and Burnt Sienna to lay in the shadows and cracks in the stone wall. Then, working around the flowers and stems, lay in light washes of warm yellows over the stones. Vary the colors and the amount of water you put down to add interest.

## 6. Work the flower arrangement

When the washes on the wall are completely dry, begin to put in the flowers in the arrangement. Work each flower one at a time, varying the colors as they're shown here, but leaning toward warm yellow-orange, orange and warm green to offset all of the blues. The pinks are mixtures of either Alizarin Crimson and Chinese White or Opera and Chinese White. Remember to work around the whites of the daisies.

## 7. Paint the background flowers

The impatiens growing out of the wall on the upper right are much cooler. Use Alizarin Red and Opera for the flowers, and mix up light and dark cool greens for the leaves by combining Cadmium Lemon, Cerulean and Oxide of Chromium as well as Sap Green and Ultramarine Blue. Use small brushes and progress slowly and carefully so you don't lose track of the individual blossoms or the larger, overall shape.

## 8. Cast the shadows

Use that favorite standby gray — Cerulean mixed with Vermilion — to lay in the cast shadows that appear throughout the painting. Remember to make each shadow shape darker as it gets closer to the corresponding object. Your work should be taking shape now.

## 9. Increase the heat

You still need more touches of oranges, so use warmer yellow, orange and red mixes for the fruits in the basket, as well as the handles of the yellow-orange utensils. While these washes are drying, start mixing up Cadmium Orange cooled with Opera or Alizarin Crimson to paint in the melon wedges in the bowl. Then use various combinations of Raw and Burnt Sienna to paint in the basket, adding touches of Cerulean on the shadowed side.

## 10. Add the other elements

By now, you've had a lot of experience mixing grays and other colors repeated throughout this painting. Use this knowledge to mix the right colors for the flower jug, book and remaining dishes and silverware. You might want to simplify some of the details within these objects. As always, watch out for whites and work around them.

## 11. Refine the tablecloth

Next, mix up various combinations of Cerulean and Ultramarine to re-state and darken the checked tablecloth. When the stripes have dried, use light glazes of the same colors to develop the folds and shadowed areas. Compare your painting to my original to make sure you've got the values correct.

## 12. Complete the background

Use stronger Cadmium Orange, Cadmium Yellow Deep and Raw Sienna, as well as these colors mixed with Burnt Sienna, Cerulean and/or Ultramarine, to intensify the stone wall until it matches mine. Use a light touch to suggest the texture of stone. And finally, compare your painting against the original. Add glazes to adjust colors, darken values and refine details as needed.

**Cadmium Yellow Deep**    **Cadmium Orange**

**Raw Sienna + Cerulean glaze**

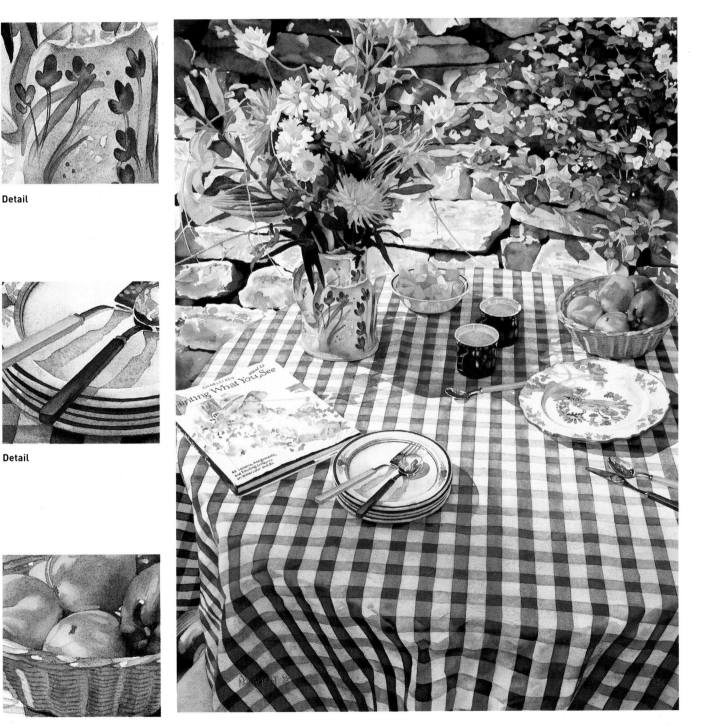

**Detail**

**Detail**

**Detail**

*Reid's View of My Wall*, watercolor, 29 x 21" (74 x 54cm) by William C. Wright ©

# art map 4
## Shadow designs

Before you begin, read the entire project through so you know what's going to happen next.

Early one spring, I arranged this set-up in a sunny bay window in our home. I was attracted by the design of the cast shadows, especially the dramatic, geometric shapes created by the window mullions.

I focused on color contrasts for this one. To enhance the rich, warm color of the table, I chose a warm peach-pink for the tulips and balanced all of the warms with cooler greens in the foliage. Notice how the blue-grays of the Paul Revere bowl and the glass egg mirroring the nearby silver echo the colors of the window's woodwork. It's as if they create a cool frame around the dominant yellows and browns.

This painting is loaded with detail, especially in the flowers, bowl and wooden table. Take your time to recreate this one. Don't try to do it all in one sitting. You can take frequent breaks and come back to it again and again until you've successfully completed your painting.

### 1. The image to be transferred using the art map

Read the instructions to see how to map this image across to your paper.

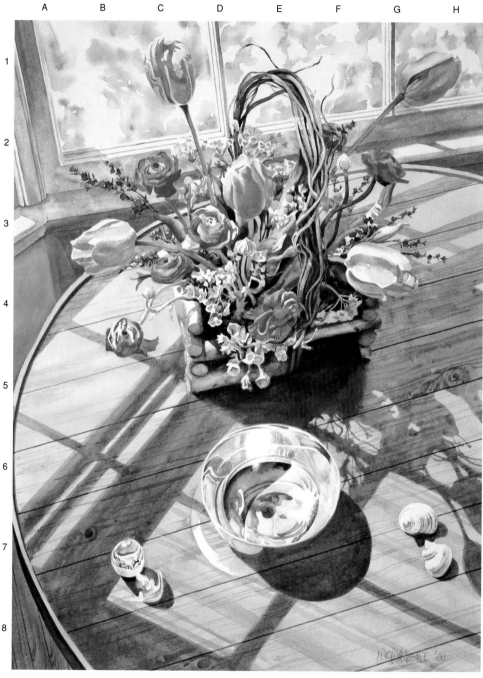

## 2. Mapping the image

First, study how this painting has been divided into a grid. The painting's grid has been evenly divided into 8 horizontal rows and 8 vertical columns. Notice how the grid has been referenced with numbers and letters — just like a map. My painting was 16 x 12" (41 x 31cm), but you can use larger or smaller paper for this exercise, provided your paper is the same proportion as the original painting.

## 3. Use the art map to transfer the image

Now make a corresponding grid on your watercolor paper. Letter and number the grid, using a HB pencil and drawing very lightly. Next, start copying the drawing box by box, referring to the grid reference letters and numbers as needed. Hint: Start by positioning the main shapes first, then lightly add the rest. You don't have to draw every single detail — just get the main shapes down.

**By using this method, you can enlarge or reduce the image to any size you want.**

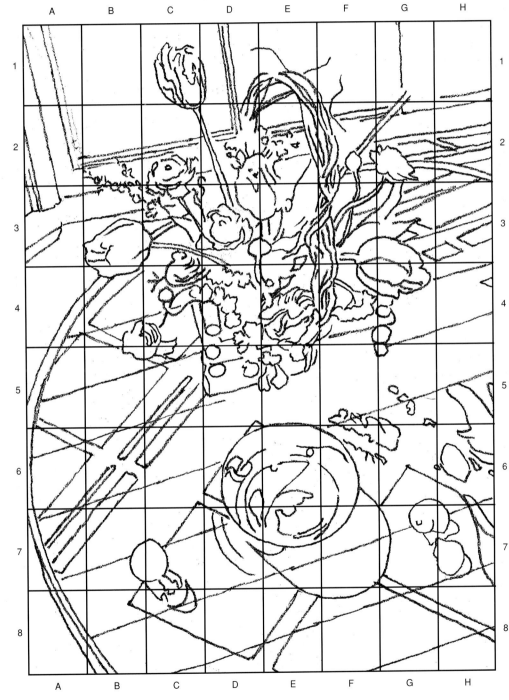

**This is how your art map should look.**
Here I've done the drawing quite heavily so you can see the idea, but you will do this lightly in pencil.

# Study these pages before you start painting

**Shape map**
Objects for a still life should always be chosen with great care. Here, all of the oval and circular shapes balance the straight lines of the windows and their cast shadows. They create a swirling effect, linking the various parts of the painting together.

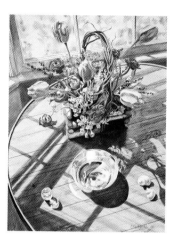

**Tonal value map**
This is what's known as a high-key painting. Most of the tonal values fall into the high, or light, end of the scale. Even the darkest area, the shadowed side of the basket, is not completely dark.

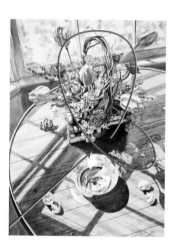

**Movement map**
I love to design around cast shadows. Study how effectively these shadows attract and guide your eye around the painting.

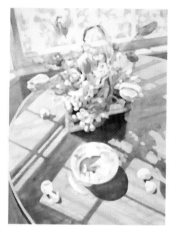

**Color map (squint)**
The contrast of temperatures is very important in this painting. Keep this in mind as you paint the warm tabletop and flowers and the cool greenery and shadows. Remember to keep your colors clean and fresh.

## materials you'll need

**paper**
140lb (300gsm) hot-pressed or 300lb (638gsm) cold-pressed

**brushes**
nos. 1 through 8 sable rounds

**other tools**
HB pencil

gum eraser

ruler

paper towels

test scrap of same watercolor paper

## your palette for this painting

Aureolin
Cadmium Lemon
Cadmium Yellow Deep
Naples Yellow
Raw Sienna
Burnt Sienna
Cerulean Blue
Ultramarine Blue
Prussian Blue

Vermilion or Bright Red
Cadmium Red Deep
Alizarin Crimson
Opera or Magenta
Phthalo Violet
Sap Green
Hookers Green Dark
Oxide of Chromium
Chinese White

# Consider the following elements

## Light source

Set up right next to a window, this arrangement is getting plenty of warm, direct light from the left. Notice how it keeps all of the tonal values quite light.

## Viewpoint

This viewpoint was chosen because it took the best advantage of the interconnecting design of the cast shadows.

## Bright idea

Green is one of the toughest colors to deal with. Whenever you have a chance, you might want to experiment with mixing greens by combining yellows, blues and hints of other colors. You'll soon learn how to get just the right green for anything you're painting. Tube greens can look harsh and unnatural, so save them for last if you need a shot of brighter green.

## ! Beware

A color can look perfect when you mix it on the palette, but turn out to be anything but when you lay it on your paper. And then you're pretty much stuck with it! That's why I recommend keeping a scrap sheet of watercolor paper nearby. You can test your mixed colors first before applying them to your painting.

## 4. Cover the tabletop

To begin, lay in a light wash over the entire tabletop, working around the objects. Since the light is strongest toward the upper left, use predominantly Cadmium Yellow Deep there. Then, gradually transition into a combination of Cadmium Yellow Deep and Raw Sienna, and finally use mostly Raw Sienna on the right. This is just a foundation underpainting, so you don't need to include any details.

**Cadmium Yellow Deep**

**Cadmium Yellow Deep + Raw Sienna**     **Raw Sienna**

# Put it all together

## 5. Start the main flowers

One at a time, put in the salmon tulips and red flowers in the bouquet, using the color mixes as shown. When the initial washes have dried, glaze on the shadows by mixing these same colors with Cerulean Blue and Vermilion.

## 6. Add to the bouquet

Paint in the small purple flowers with Alizarin and Phthalo Violet, and the pink flowers with a combination of Alizarin and Chinese White.

## 7. Go for the greens

When all of the flowers have dried, paint in the greenery around them. Use a mixture of Cerulean Blue and Cadmium Lemon for a cool base color, then add Raw Sienna wherever the stalks and leaves are touched by the sun. For the darker gray-greens in the shadows, use combinations of Oxide of Chromium and touches of Sap Green and Ultramarine Blue. While you have these greens on your palette, complete the greenery outside the window by using the two-brush method. Lay in the water in a random pattern, then drop in light greens and touches of blue-green, tilting the board to let the colors mingle.

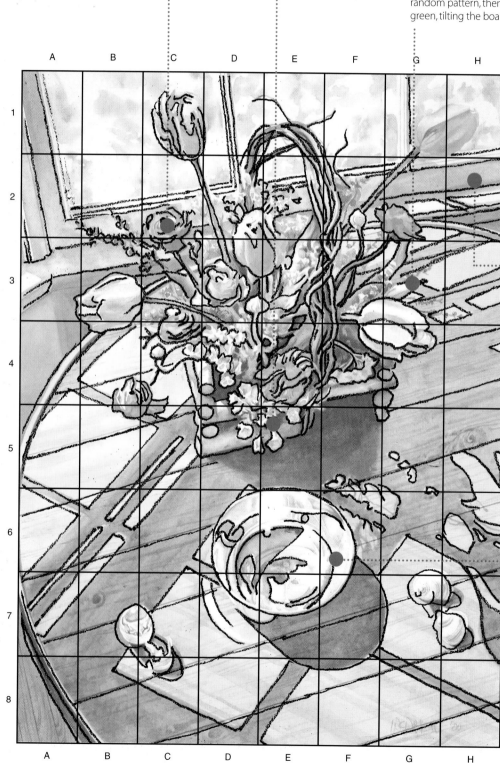

## 8. Fill the basket

When the bouquet is dry, go back in and complete the basket. Use Raw Sienna and touches of light gray-blue as the base, and add a dark mixture of Burnt Sienna and Ultramarine for the details and shadows.

## 9. Frame the window

To create the window frame, paint a base coat of your standby gray-blue mixture of Cerulean Blue and Vermilion. To intensify the color with later glazes, add Ultramarine Blue and Burnt Sienna to this mixture. When the window frame area has dried, paint in the wall with the dark salmon mixture of Naples Yellow, Cadmium Red Deep and Alizarin Crimson, adding Cerulean Blue as the wall drops into shadow.

## 10. Paint the foreground objects

To mix a foundation color for all of these objects, mix Cerulean Blue with Vermilion. Then mix Ultramarine Blue and Burnt Sienna for their shadowed sides. Study my painting carefully before you finish. Note where the colors from the flowers, tabletop and other objects are reflected in these shiny surfaces. Repeating the colors here will help unify the painting.

## 11. Finish the table

Now that all other objects are in place, go back and put in the cast shadows on the tabletop. Use a combination of Burnt Sienna with varying amounts of Ultramarine. Apply two or more coats of light washes, letting each layer dry before adding more, to build the right depth of color. When dry, apply the lines of the wood grain with Raw Sienna in the sunlit areas and dark Burnt Sienna in the shadows.

**Detail**

**Detail**

**Detail**

**Detail**

**Detail**

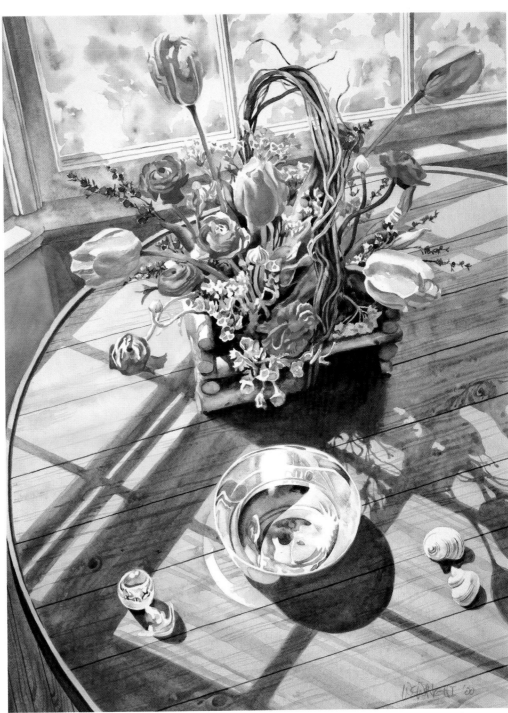

*Tulip Bouquet With Bowl*, watercolor, 16 x 12" (41 x 31cm) by William C. Wright ©

# art map 5

## Warmed by the sun

Before you begin, read the entire project through so you know what's going to happen next.

Here you see the same wooden table and bay window from the previous project, only the mood is slightly different now. Because it's February, the light is weaker, casting long shadows across the table. To warm things up, I chose objects that make me feel warm, like pumpkin pie with whipped cream and shiny, reflective objects.

This painting is also about shapes and design. Again, notice how I chose a variety of shapes and arranged them in an interesting way. Even the cast shadow shapes become part of the design. To tie things together, I chose objects that are mostly gray or blue-gray, including the book about Richard Diebenkorn's art. Repeated colors always help to unify a painting.

If you'd like, you could substitute your own book covers here. But you may want to choose something dark to maintain the balance of the value pattern and something simple so you don't get caught up in difficult detail. And be sure to repeat the colors from your covers elsewhere in your painting.

## 1. The image to be transferred using the art map

Read the instructions to see how to map this image across to your paper.

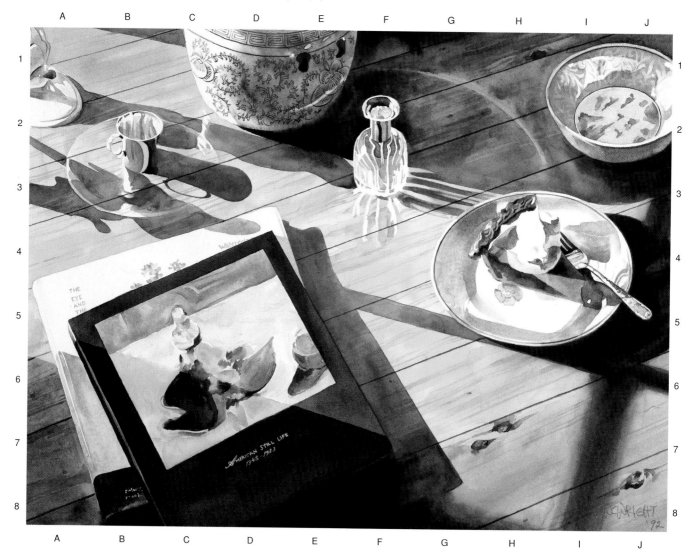

30

## 2. Mapping the image

First, study how this painting has been divided into a grid. The painting's grid has been evenly divided into 8 horizontal rows and 10 vertical columns. Notice how the grid has been referenced with numbers and letters — just like a map. My painting was 12 x 16" (31 x 41cm), but you can use larger paper for this exercise, provided your paper is the same proportion as the original painting.

## 3. Use the art map to transfer the image

Now make a corresponding grid on your watercolor paper. Letter and number the grid, using a HB pencil and drawing very lightly. Next, start copying the drawing box by box, referring to the grid reference letters and numbers as needed. Hint: Start by positioning the main shapes first, then lightly add the rest. You don't have to draw every single detail — just get the main shapes down.

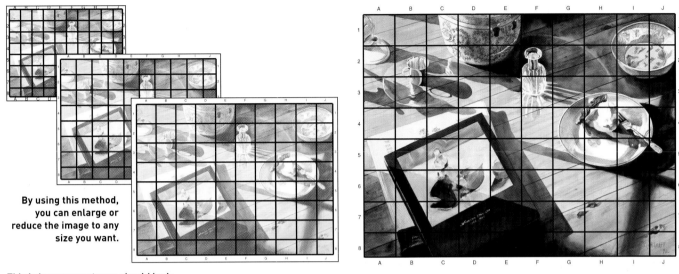

**By using this method, you can enlarge or reduce the image to any size you want.**

**This is how your art map should look.**

Here I've done the drawing quite heavily so you can see the idea, but you will do this lightly in pencil.

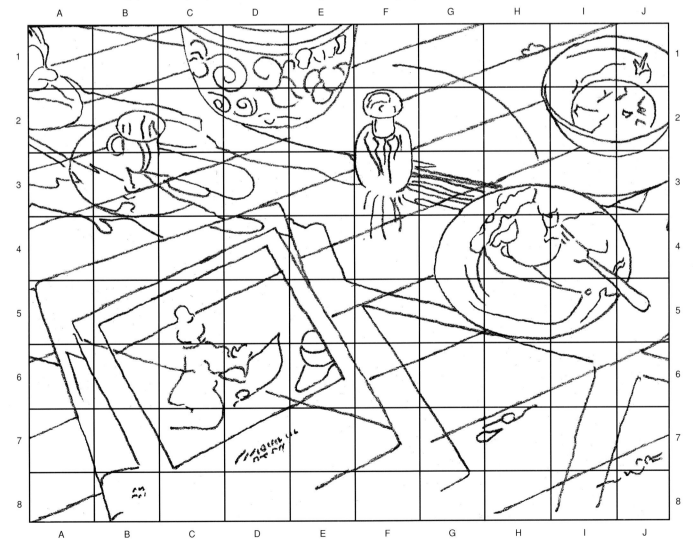

# Study these pages before you start painting

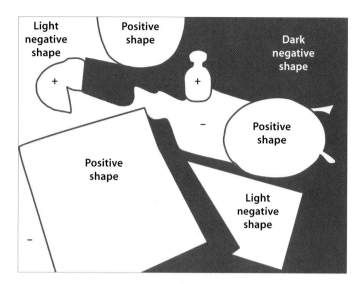

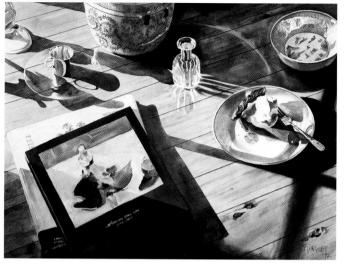

**Shape map**
Artists often talk about positive and negative shapes. Typically, the positive shapes are the main objects and their shadows. The negative shapes are the large areas surrounding these main elements. Here, the negative shape is divided into two shapes — one light and one dark — that weave together across the painting. It makes for a very dynamic design.

**Tonal value map**
Here, you can see that you'll be using the full value scale from white to black. You're going to need several layers of paint in the darkest areas to achieve that depth of value.

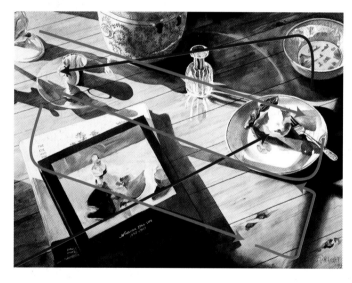

**Movement map**
Strong diagonals always lend a lot of movement to a painting. Our eyes tend to follow straight lines quickly, so we're led in an exciting, zigzagging pattern by the shadows here. However, the objects also line up in implied diagonals running the opposite way — contrast!

**Color map (squint)**
Remember, the mood here is cozy warmth on a winter's day. That's why there are mostly warm neutrals with only a few touches of bright colors and cooler tones for balance.

## materials you'll need

### paper
140lb (300gsm) hot-pressed or
300lb (638gsm) cold-pressed

### brushes
nos. 1 through 8 sable rounds

### other tools
HB pencil

gum eraser

ruler

paper towels

test scrap of same watercolor paper

## your palette for this painting

Aureolin
Cadmium Lemon
Cadmium Yellow Deep
Naples Yellow
Raw Sienna
Burnt Sienna
Cerulean Blue
Ultramarine Blue
Prussian Blue

Vermilion or Bright Red
Cadmium Red Deep
Alizarin Crimson
Opera or Magenta
Phthalo Violet
Sap Green
Hookers Green Dark
Oxide of Chromium
Chinese White

# Consider the following elements

## Light source

The winter sunlight angling in from the upper left window is essential to the diagonal design of this painting. Because winter sun is weak, it casts long, interesting shadows.

## Viewpoint

Looking down on the objects from a 45-degree angle is perhaps my favorite vantage point. More often than not, it allows me to make the best use of the interesting variety in my shapes.

## Bright idea

Crystal and cut-glass objects, such as the small vase and silver cup near the center of this painting, tend to project white light around them, which I call haloes. Always make note of haloes before you start painting so you can remember to paint around the whites.

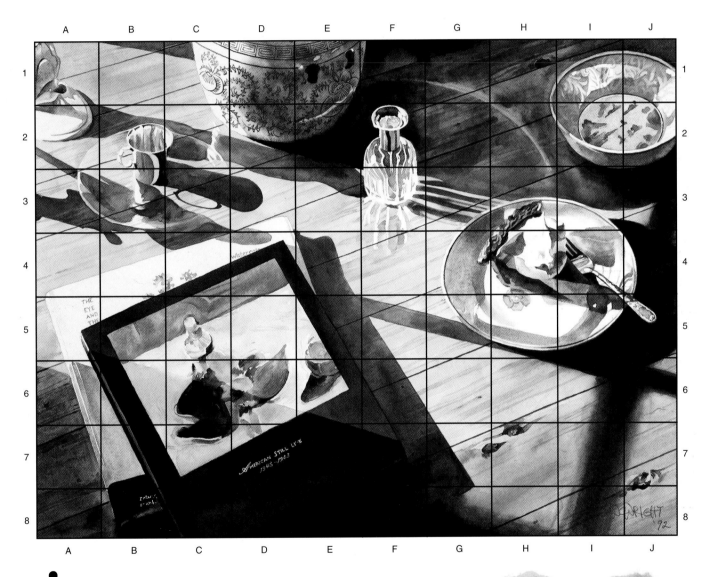

## ! Beware

You're going to be using the same color combinations repeatedly in this painting, so take care you don't run out before you're finished. Consider using a large porcelain dish to mix the more complicated colors. The dishes are heavy enough not to spill when mixing and deep enough to allow for large quantities of paint.

## 4. Warm up the wood

Start with a light wash of Cadmium Yellow Deep and Raw Sienna on the tabletop, carefully painting around the white halo and other objects. This is just an underpainting, so you don't need to include any details.

**Cadmium Yellow Deep**

**Cadmium Yellow Deep + Raw Sienna**

# Put it all together

### 5. Keep edges soft

While this warm underpainting is still damp, start laying in a cool, light wash of Cerulean Blue and Vermilion, plus touches of Raw Sienna, on all of the objects. Letting the damp colors bleed slightly will generate soft edges where the objects meet up with the tabletop.

**Cerulean Blue + Vermilion**

**Cerulean Blue + Vermilion + Raw Sienna**

### 6. Make a pie

When the wash on the pie plate is dry, start painting the details on the pie piece. Use Raw Sienna for the sunlit side, and Burnt Sienna with a little Ultramarine Blue for the shadowed side. Mix Cerulean and Vermilion for the shadows in the whipped cream, and add just a hint of warmer color to show some reflected light in the whites. Use Cerulean to intensify the other shadows found around the plate.

**Raw Sienna**

**Cerulean Blue + Vermilion**

### 7. Start a good book

You can choose to paint any book cover designs here, but you may want to follow mine fairly closely because they balance the image in terms of color and value. Use Cerulean and Ultramarine for the blues, Naples Yellow and Chinese White for the sand-colored areas and Ultramarine and Violet for the shadows on the top cover. Try to match the other colors on your own.

**Burnt Sienna + Ultramarine**

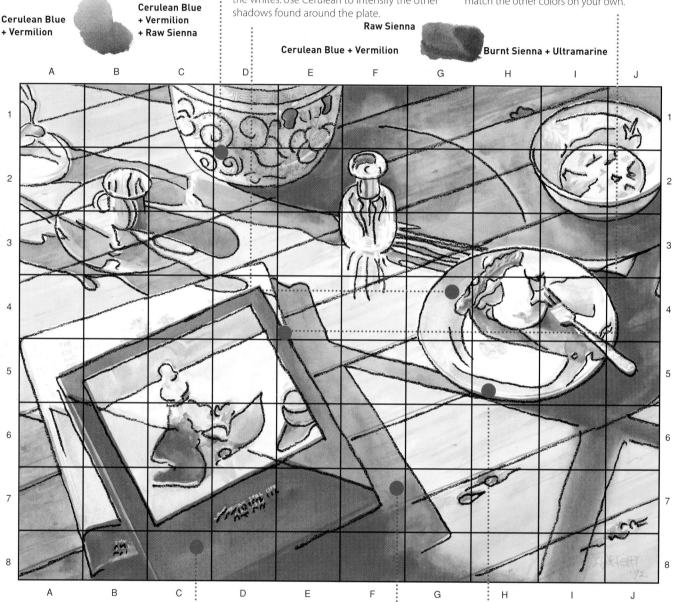

### 8. Move to black

Once the cover areas have dried, complete the books by layering on several light coats of a mixture of Ultramarine and a touch of Burnt Sienna. Let each layer dry thoroughly before adding another. You have three options for creating the lettering: 1) apply masking fluid and let dry before you paint, 2) paint with designer's gouache over the black, or 3) paint around it, as I did.

### 9. Cast the shadows

Use the two-brush method to put in the cast shadows falling to the right of the objects so you get nice, soft edges. For the shadows closer to the foreground, use Burnt Sienna mixed with touches of Ultramarine or Phthalo Violet. For the darker shadows in the background, use darker mixtures of the same colors and layer as needed to get the darkest values.

**Ultramarine + Burnt Sienna**

### 10. Complete the objects

Now, using smaller brushes, go back and define the details among all of the smaller objects. Remember to repeat colors — the pink flower on the pie plate is the same as the pink on the book cover, the blues and greens in the Chinese porcelain also pick up the cover colors. Notice, too, that the silver cup reflects the warm table color.

## 11. Detail the wood

To create the planks, grain and knotholes in the wood, use various combinations of Ultramarine and Burnt Sienna. Use small brushes and a steady hand, and remember to work around the white haloes.

**Burnt Sienna + Ultramarine Blue**

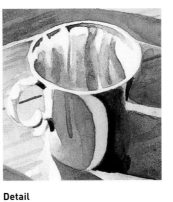

Detail

Detail

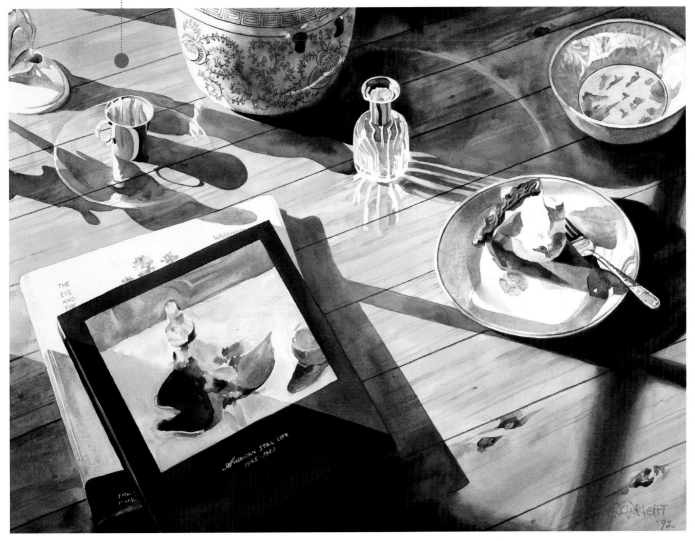

*Pie in February*, watercolor, 12 x 16" (31 x 41cm) by William C. Wright ©

Detail

Detail

Detail

35

# art map 6

## Sweet summer memories

**Before you begin, read the entire project through so you know what's going to happen next.**

While visiting my in-laws' old summer house one year, a friend brought us this gift of sweet peas. Even now, this painting remains one of my favorites because it brings back fond memories of that summer.

Of course, I'm also enamored with the design of this one. It's filled with contrasts. First, there's the contrast of the colorful flowers and the crisp white of the bench. I also like the differences between the round shape of the vase, the random contour of the chaotic mass of flowers and the neat, orderly lines of the architectural elements.

When you go to recreate this painting, don't feel as if you have to be completely accurate with these flowers. Sweet peas are floppy flowers, so any colorful sweep at the end of a green stem will read as a flower for the viewer. However, you might want to take a bit more care with the stems and leaves. These are often what identify a flower's type, so let your viewers know these are climbing vines with curly tendrils. If you're not confident about your ability to paint around these fine lines, you may want to consider using masking fluid to preserve them, then paint them in later.

## 1. The image to be transferred using the art map

Read the instructions to see how to map this image across to your paper.

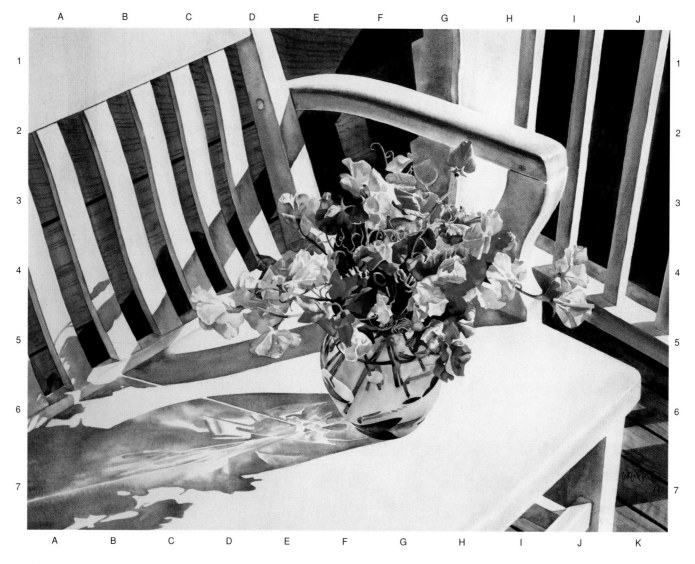

## 2. Mapping the image

First, study how this painting has been divided into a grid. The painting's grid has been evenly divided into 7 horizontal rows and 10 vertical columns. Notice how the grid has been referenced with numbers and letters — just like a map. My painting was 16 x 21" (41 x 54cm), but you can use larger or smaller paper for this exercise, provided your paper is the same proportion as the original painting.

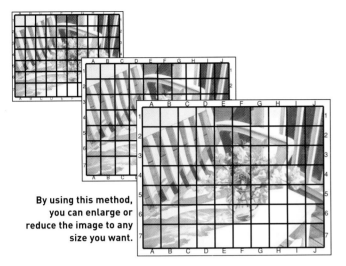

**By using this method, you can enlarge or reduce the image to any size you want.**

## 3. Use the art map to transfer the image

Now make a corresponding grid on your watercolor paper. Letter and number the grid, using a HB pencil and drawing very lightly. Next, start copying the drawing box by box, referring to the grid reference letters and numbers as needed. Hint: Start by positioning the main shapes first, then lightly add the rest. You don't have to draw every single detail — just get the main shapes down.

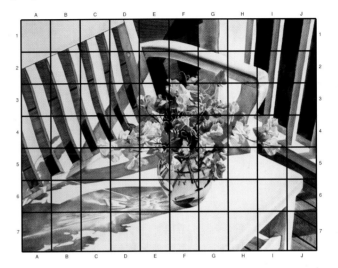

**This is how your art map should look.**

Here I've done the drawing quite heavily so you can see the idea, but you will do this lightly in pencil.

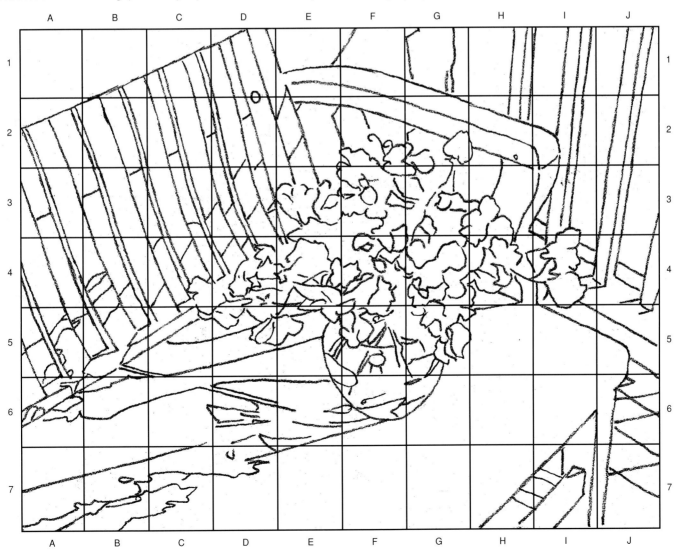

# Study these pages before you start painting

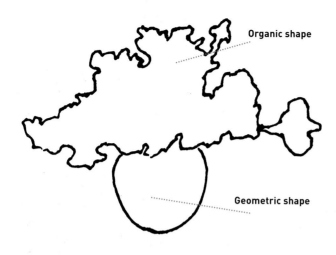

Organic shape

Geometric shape

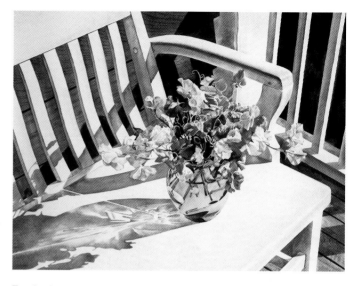

### Shape guide
Perhaps I should explain the two types of shape I usually deal with. Geometric shapes are the standards we all know — circles, rectangles, triangles and so on. An organic shape, however, is any shape with a meandering, unexpected contour, like the bunch of flowers. Notice how I've included both here.

### Tonal value map
Wow! This painting has a lot of near-white and a lot of near-black values, and not much in between. What do you think? I think it gives the painting a lot of visual punch, just right for the bright summer feeling I was after.

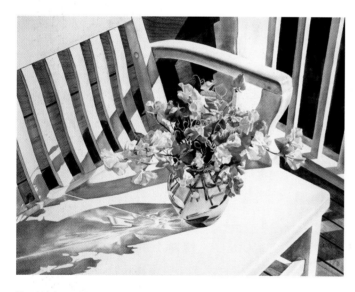

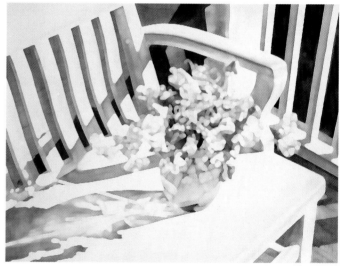

### Focal point guide
Just glancing at this painting, where does your eye go first? Why? Contrast of some kind is always the thing that will attract your attention, and here it's the bright color in the midst of all that white. That contrast identifies the flowers as the focal point, the most important part of the painting.

### Color map (squint)
By looking at this blurred version of the painting, you can forget about the objects you're seeing and focus on just the color. It will help you see how much color is woven into the whites of the bench and railing.

## materials you'll need

**paper**
140lb (300gsm) hot-pressed or
300lb (638gsm) cold-pressed

**brushes**
nos. 1 through 8 sable rounds

**other tools**
HB pencil

gum eraser

ruler

paper towels

test scrap of same watercolor paper

## your palette for this painting

Aureolin
Cadmium Lemon
Cadmium Yellow Deep
Naples Yellow
Raw Sienna
Burnt Sienna
Cerulean Blue
Ultramarine Blue
Special: Phthalo Green

Vermilion or Bright Red
Cadmium Red Deep
Alizarin Crimson
Opera or Magenta
Phthalo Violet
Sap Green
Hookers Green Dark
Oxide of Chromium
Chinese White

# Consider the following elements

## Light source
This time, the sun is high in the sky to the right of the arrangement. That means all of the shadows will fall directly to the left.

## Viewpoint
I chose a viewpoint that angled the straight lines in toward the sweet peas, as if they're arrows directing your eye to the focal point.

## Bright idea
Keep the initial washes soft and loosely defined. It's best to wait to define your harder edges and darker values later in the painting, once you're sure of what you want.

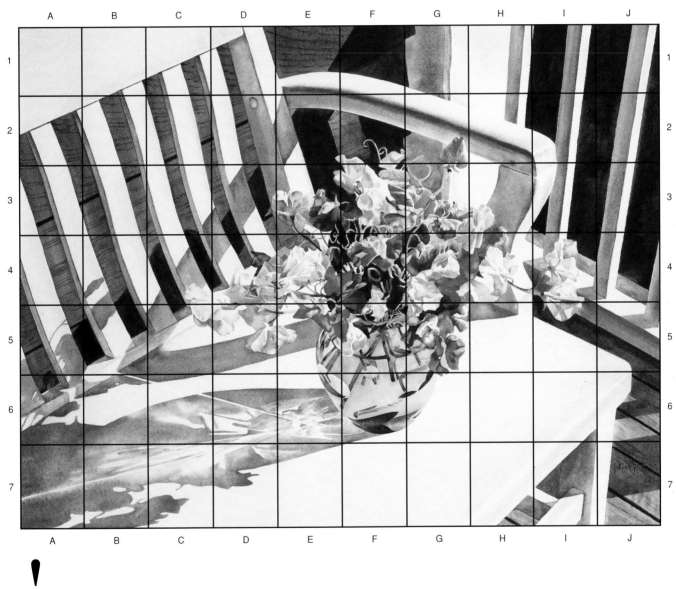

## ❗ Beware
White objects need a hint of color to make them look convincingly real, but don't get too carried away. Keep your touches of color subtle.

## 4. Define the white objects
Using variations of the standard blue-gray mix of Cerulean Blue and Vermilion, lay in a light wash to start defining the shadowed sides and areas of the white objects. Build the color slowly and don't go too dark yet.

**Cerulean Blue + Vermilion**    **With more Vermilion**

# Put it all together

## 5. Go crazy with color

The flowers are the only brightly colored part of this painting, so have fun with them. You're going to use many of the same mixes you've used in the previous projects: Cerulean Blue and Vermilion for the white flowers; Alizarin and Chinese White, Opera and Chinese White, and touches of Cerulean or Ultramarine for the pinks; Cadmium Red Deep and Alizarin Crimson for the reds; and Cerulean Blue and Phthalo Violet, and Cerulean and Alizarin for the purples.

## 6. Add the vase

After the flowers are dry, lay in the vase with Phthalo Green alone and mixed with Cerulean Blue on the shadowed side. Notice how the indentations in the surface and the water line distort your view of the stems inside. Let this dry thoroughly before continuing.

**Phthalo Green + Cerulean Blue**

## 7. Complete the bouquet

Mix up all of your greens first, then work on one stem at a time so you can apply additional colors wet-into-wet. Start with a mix of Cerulean Blue and Cadmium Lemon for a base color. Make the curly tendrils a more intense yellow. Then layer some Sap Green along with Raw Sienna wet-into-wet for the shadowed sides of the stems. Glaze these colors right over the vase color for the stems under the water. For the dark leaves, use Hookers Green Deep and Ultramarine Blue.

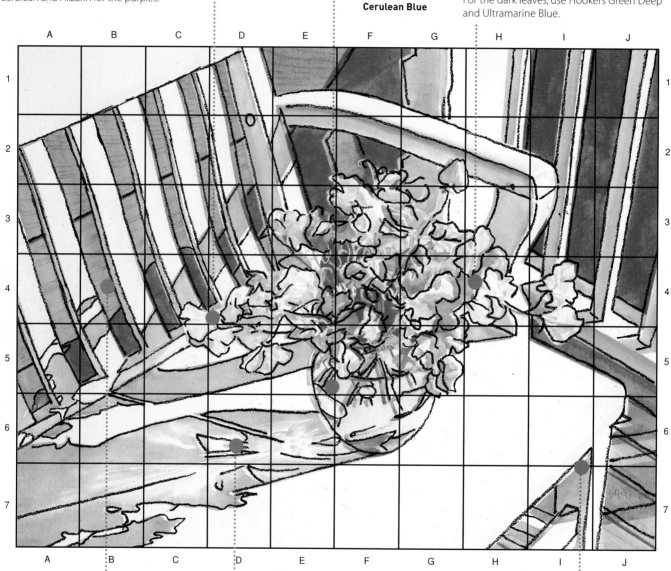

## 8. Start the background

For the house siding behind the bench, mix a gray that leans toward brown out of Burnt Sienna and Ultramarine Blue. Use this same mixture to lay in the first wash of dark area to the right, behind the railing. For the floor, use a combination of Cerulean Blue, Vermilion and Oxide of Chromium.

## 9. Put in the cast shadows

While the background is drying, go back and put in the cast shadows across the bench. Mix up a light value of Cerulean and Vermilion, and then create a medium and a dark value by adding Burnt Sienna and Ultramarine to this same mixture. Apply these colors as you see them done here on the shadows, working around white areas as needed. While the shadow behind the vase is still wet, drop in a few touches of reflected color, such as yellow-green and pink. Before the other shadows dry, drop in Raw Sienna along the edges to provide some warm accents.

## 10. Enhance the definition

Continuing to use slightly darker versions of the same mixes you've been using, glaze on more layers of color to the bench, siding, floor and cast shadows until you feel you've adequately defined these shapes.

## 11. Dive into the darks

To complete the darkest areas of the background seen through the railing, squeeze out fresh Burnt Sienna and Ultramarine Blue from their tubes. Mix them together in a dark wash, and repeatedly layer this mixture on until you've got it as dark as you want it. Note, however, that there are subtle variations in these washes to suggest shrubbery. Remember to allow the layers to dry between applications.

**Burnt Sienna**

**Burnt Sienna + Ultramarine Blue**

**Ultramarine Blue**

**Detail**

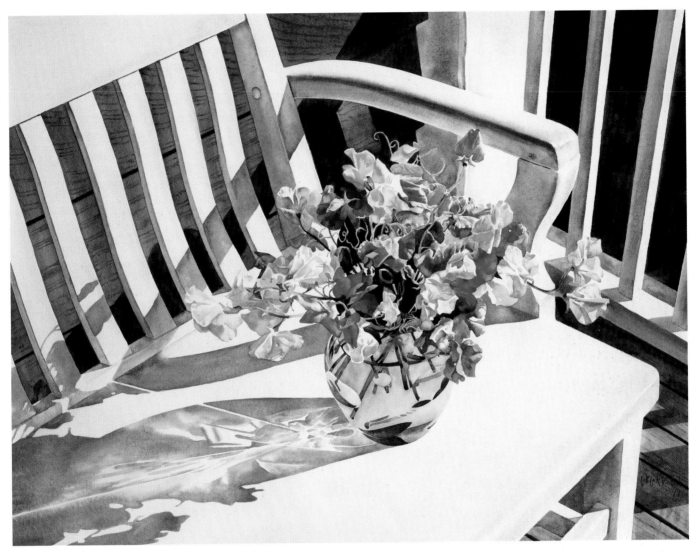

*Sweet Peas on the Porch*, watercolor, 16 x 21" (41 x 54cm) by William C. Wright ©

**Detail**

**Detail**

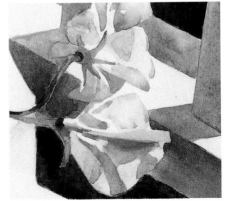

**Detail**

# art map 7
## Cool and light

Before you begin, read the entire project through so you know what's going to happen next.

Just as I did with the first project, Under the Cherries and Lilacs II (page 6), I built this painting around the cool, yet vivid, colors of spring flowers. To support this theme, I positioned my colorful bouquet and supporting objects on a tile table that was custom made by my sister in my favorite color.

As always, all that coolness needs some relief in the form of warm colors. Although the daffodils are a cool yellow, they are relatively warmer than the other colors and provide a nice transition to the warm yellow-greens and greens in the background.

At first, you may think this painting is too much of a challenge for you, but don't give up now. Use the grid to make sure you get the drawing and perspective of the tiles and other objects right before you start painting. And there's no need to worry about painting those straight edges. The edges of the tiles have slight waves, so it's okay if your brushstrokes are a little uneven. Then, look closely at the handrails and you'll see how my edges aren't perfectly straight. Would you have noticed if I hadn't pointed it out? Neither will your viewers.

## 1. The image to be transferred using the art map

Read the instructions to see how to map this image across to your paper.

## 2. Mapping the image

First, study how this painting has been divided into a grid. The painting's grid has been evenly divided into 7 horizontal rows and 10 vertical columns. Notice how the grid has been referenced with numbers and letters — just like a map. My painting was 16 x 21" (41 x 53.5cm), but you can use larger or smaller paper for this exercise, provided your paper is the same proportion as the original painting.

**By using this method, you can enlarge or reduce the image to any size you want.**

## 3. Use the art map to transfer the image

Now make a corresponding grid on your watercolor paper. Letter and number the grid, using a HB pencil and drawing very lightly. Next, start copying the drawing box by box, referring to the grid reference letters and numbers as needed. Hint: Start by positioning the main shapes first, then lightly add the rest. You don't have to draw every single detail — just get the main shapes down.

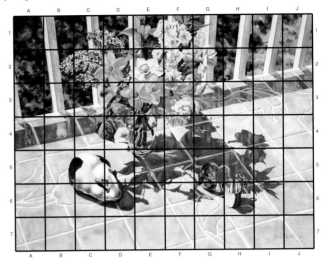

**This is how your art map should look.**

Here I've done the drawing quite heavily so you can see the idea, but you will do this lightly in pencil.

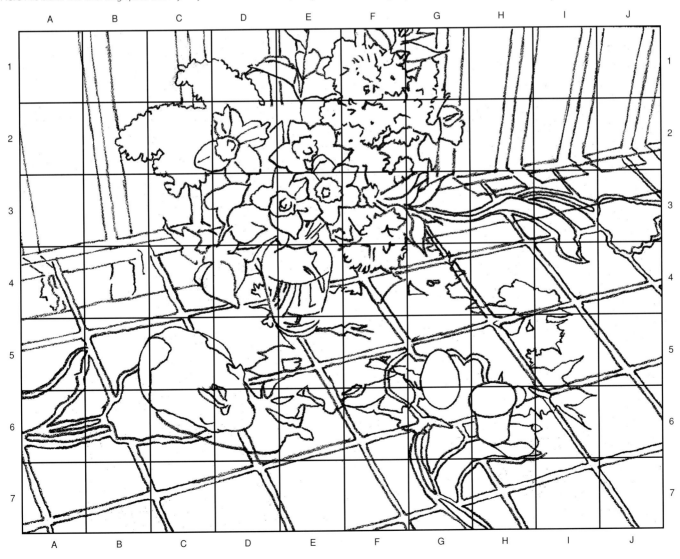

# Study these pages before you start painting

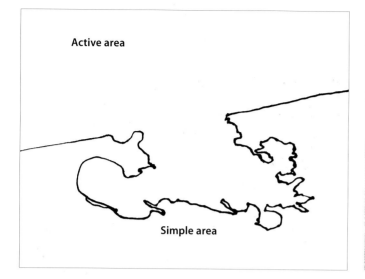

**Balance blueprint**
Notice how I've clustered the busy bouquet, its' complicated cast shadow and the other objects near the light/dark repetition of the handrails. Then look at how simple the rest of the painting is. Simplified areas are needed to balance active, complex subjects.

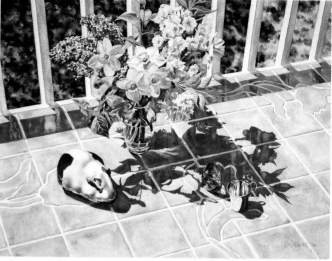

**Tonal value map**
This painting contains a lot of areas of extreme tonal contrast. Think about how this affects your eye, sweeping it around the painting.

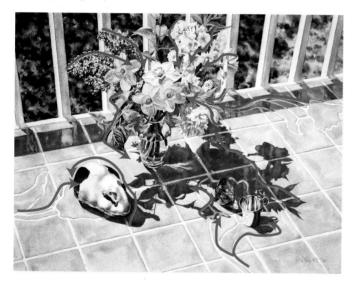

**Line map**
Curving lines — often called lyrical lines in art — abound here. They provide a gentle flow for the eye to follow into the focal point and around this painting.

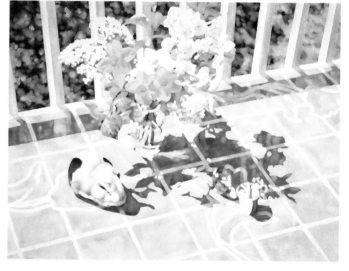

**Color map (squint)**
Dominant cool tones bring a wonderful harmony to this painting, but some warmer yellows, yellow-greens and greens offer some balance.

## materials you'll need

**paper**
140lb (300gsm) hot-pressed or 300lb (638gsm) cold-pressed

**brushes**
nos. 1 through 8 sable rounds

**other tools**
HB pencil

gum eraser

ruler

paper towels

test scrap of same watercolor paper

## your palette for this painting

Aureolin
Cadmium Lemon
Cadmium Yellow Deep
Naples Yellow
Raw Sienna
Burnt Sienna
Cerulean Blue
Ultramarine Blue
Prussian Blue

Vermilion or Bright Red
Cadmium Red Deep
Alizarin Crimson
Opera or Magenta
Phthalo Violet
Sap Green
Hookers Green Dark
Oxide of Chromium
Chinese White

# Consider the following elements

## Light source

Bright sunlight coming from the back left creates highlights on the rear tops of the flowers and casts long shadows toward the lower right.

## Viewpoint

In a very subtle way, even the design of the table top contributes to the flowing, undulating patterns within this piece. The tiles really show from this angle.

## Bright idea

When you're painting a larger shape of color, such as the blue tiles, tilt your board slightly at the top so that the paint will flow toward you. Let gravity do the job of helping to control even, flat washes.

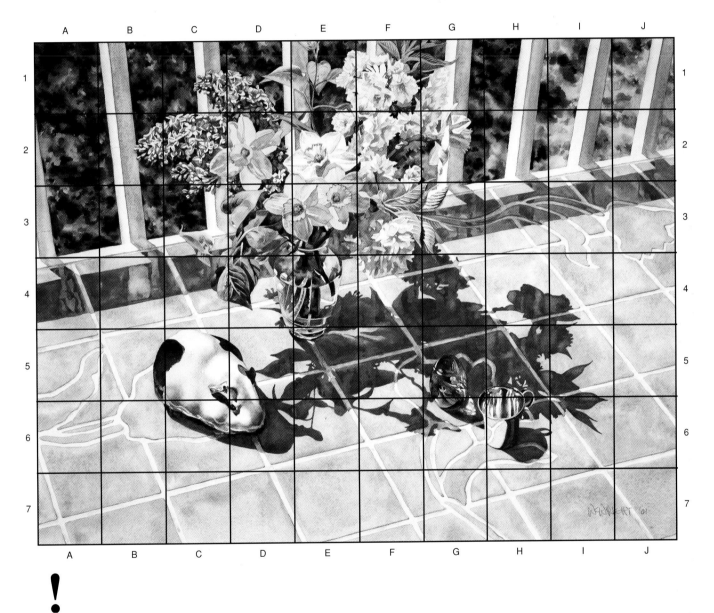

## ! Beware

Without correct drawing and perspective, this subject would never look right. When you're ready to start drawing your own complex designs, use tracing paper for your drawings. Transparent tracing paper makes it easier to correct mistakes as you re-draw until you get everything perfect.

## 4. Start with the tiles

Paint each tile individually with a light wash of Cerulean Blue, leaving the grout white. Slight variations in the color will look more realistic, especially if you add a very fine line of darker Cerulean to the front edge of each tile. While this color is on your palette, paint the small shapes of blue within the clear vase.

## 5. Define the white objects

Use a blue-gray wash of Cerulean Blue and Vermilion to define the shadowed sides of the railings, the white daffodil and the ceramic guinea pig.

# Put it all together

## 6. Develop the small objects

Continue to use this same blue-gray mix, as well as a warmer gray combination of Cerulean, Vermilion and Raw Sienna, to develop the guinea pig. Use the two-brush method to create soft edges, and let each layer dry before adding another. Use darker versions of the same two colors to paint the silver cup, carefully working around the whites. The small egg reflects a variety of cool colors from the surrounding objects.

## 7. Pick the flowers

Using the various color combinations shown in these swatches, lay a light foundation for each type of flower. Then gradually build up the details and forms with glazes.

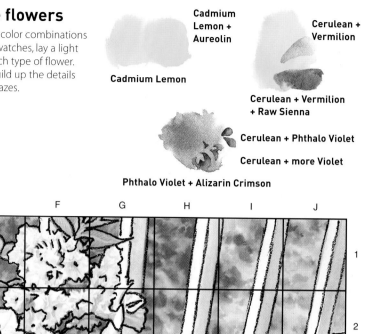

**Cadmium Lemon + Aureolin**

**Cadmium Lemon**

**Cerulean + Vermilion**

**Cerulean + Vermilion + Raw Sienna**

**Cerulean + Phthalo Violet**

**Cerulean + more Violet**

**Phthalo Violet + Alizarin Crimson**

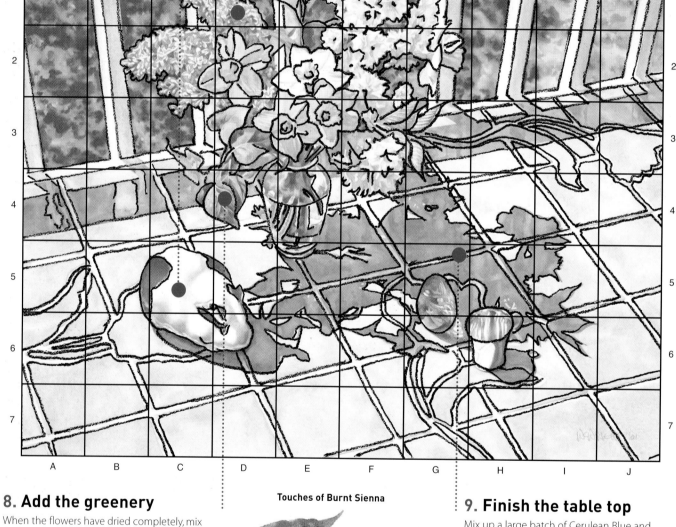

## 8. Add the greenery

When the flowers have dried completely, mix Cadmium Lemon and Cerulean to make a nice cool green as a foundation color for the leaves and stems. Working wet-into-wet, drop in touches of Burnt Sienna and Raw Sienna to suggest shadows. Don't forget the darker stems inside the vase.

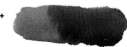

**Touches of Burnt Sienna**

**Cadmium Lemon + Cerulean**

**Touches of Raw Sienna**

**Cerulean Blue + Ultramarine**

**Touch of Burnt Sienna**

## 9. Finish the table top

Mix up a large batch of Cerulean Blue and Ultramarine, and add Burnt Sienna to a second batch of the same mixture. Work tile by tile, painting in the shadow color just on the tiles, not on the grout. In some places, drop in a bit of reflected color since the tiles are somewhat shiny and reflective. When the tile shadows are completely dry, paint in the shadows on the grout with a warm gray mixture of Cerulean, Vermilion and Raw Sienna.

## 10. Create a background

For the initial wash over the background between the railings, use a mixture of Cerulean Blue and Cadmium Lemon. Occasionally add another mixture of Aureolin and Ultramarine, working wet-into-wet to create the effect of dappled sunlight falling on the distant, soft-focus shrubs. Build up the colors in layers, keeping in mind that the areas on the far left are much darker than those on the far right. Use a dark green mix of Hookers Green and Ultramarine for the final layers on the left.

## 11. Refine and revise

Take a final look at your painting. You can adjust the color or darken the value of any area with a glaze. This is also a good time to enhance the detail if needed.

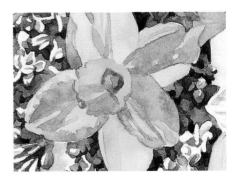

**Detail**

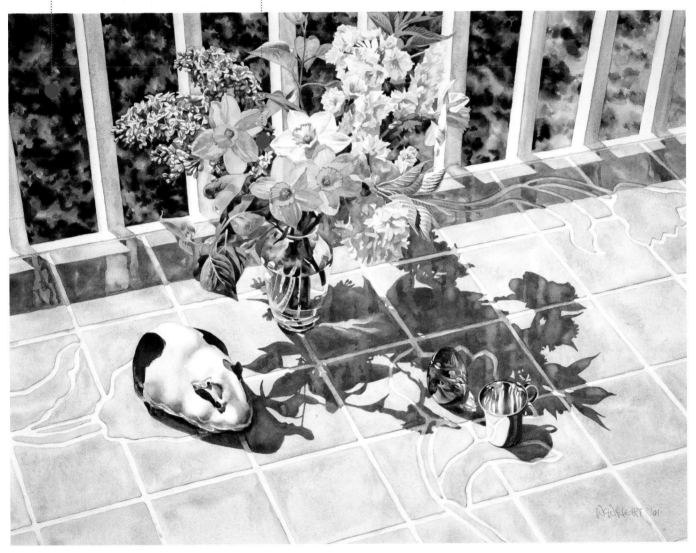

*Spring Cuttings on the Porch*, watercolor, 16 x 21" (41 x 54cm) by William C. Wright ©

**Detail**

**Detail**

**Detail**

# art map 8

## A sense of mystery

As I do with many of my paintings, I started with a beautiful bouquet of colorful flowers and a selection of other elegant objects. But this time I wanted to do something different. I decided to offset the set-up with a very rich, dark background.

First of all, the simplicity of this large shape accentuates the intricacy of the floral arrangement and especially the sweeping movement of the twig basket's handle. The dark value of the background also makes the flowers' colors look even brighter and the tabletop look even whiter. And in my opinion, the darkness adds an intriguing sense of mystery to the painting, inviting viewers to engage in the image more completely.

This is one of the few times that I will recommend using masking fluid to recreate this painting. The background needs to be done wet-into-wet, and the only way to do that effectively is to mask off the elements surrounding it. Masking fluid is the best way to achieve this look.

Before you begin, read the entire project through so you know what's going to happen next.

### 1. The image to be transferred using the art map

Read the instructions to see how to map this image across to your paper.

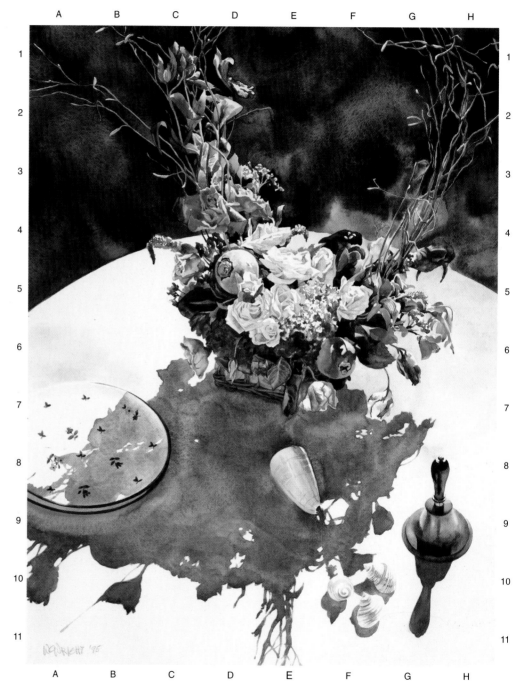

## 2. Mapping the image

First, study how this painting has been divided into a grid. The painting's grid has been evenly divided into 11 horizontal rows and 8 vertical columns. Notice how the grid has been referenced with numbers and letters — just like a map. My painting was 21 x 16" (54 x 41cm), but you can use larger or smaller paper for this exercise, provided your paper is the same proportion as the original painting.

## 3. Use the art map to transfer the image

Now make a corresponding grid on your watercolor paper. Letter and number the grid, using a HB pencil and drawing very lightly. Next, start copying the drawing box by box, referring to the grid reference letters and numbers as needed. Hint: Start by positioning the main shapes first, then lightly add the rest. You don't have to draw every single detail — just get the main shapes down.

**By using this method, you can enlarge or reduce the image to any size you want.**

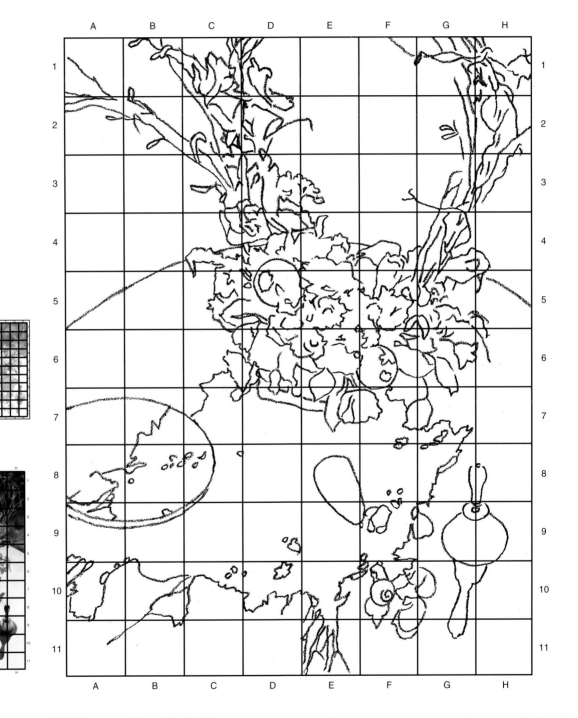

**This is how your art map should look.**
Here I've done the drawing quite heavily so you can see the idea, but you will do this lightly in pencil.

# Study these pages before you start painting

**Shape map**
Notice how the large, overlapping shapes of the round table and the oval basket unite the top half with the bottom half.

**Tonal value map**
Look at how effectively the alternating shapes of near-white and near-black make the whites stand out. That's contrast at work.

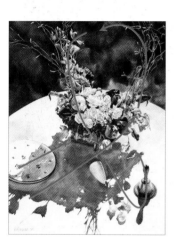

**Movement map**
Consider the angles of the shadows and the positions of every object on the table. Together, they link up to create lines that sweep your eye around this painting.

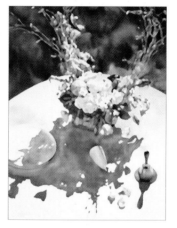

**Color map (squint)**
This painting is predominantly neutral colors, so the few colors that were used needed to be rich and intense. They look great against the black and white, giving the painting a contemporary feeling.

## materials you'll need

**paper**
140lb (300gsm) hot-pressed or 300lb (638gsm) cold-pressed

**brushes**
nos. 1 through 8 sable rounds

**other tools**
HB pencil

gum eraser

ruler

paper towels

test scrap of same watercolor paper

masking fluid

rubber cement pick-up

## your palette for this painting

Aureolin
Cadmium Lemon
Cadmium Yellow Deep
Naples Yellow
Raw Sienna
Burnt Sienna
Cerulean Blue
Ultramarine Blue
Prussian Blue

Vermilion or Bright Red
Cadmium Red Deep
Alizarin Crimson
Opera or Magenta
Phthalo Violet
Sap Green
Hookers Green Dark
Oxide of Chromium
Chinese White

# Consider the following elements

## Light source

Here, I positioned the light source from behind the objects to create a nice cast shadow. But I put it at a very high angle so that the tops of the objects catch a lot of light.

## Viewpoint

I zoomed in on the objects so that some of them break out of the edges of the painting. This encourages your eye to travel to all corners of the painting without ever leaving.

## Bright idea

Always remember that very dark shapes carry a lot of visual weight. If you're going to include a large, dark area like the background, look for ways to balance it elsewhere, as I did with the intricate and fairly dark cast shadow.

!

## Beware

The large, wet background wash may severely buckle your watercolor paper. If you're using 140lb (300gsm) paper, you may want to stretch it first: Soak the paper for about 15 minutes in cool water, then use a staple gun to secure the wet paper to a sturdy backing board.

## 4. Mask around the background

Use an old, worn brush to apply liquid masking fluid to all of the elements touching the background. Completely cover the twig handle and apply it to the flowers and tabletop bordering this large shape. Allow it to dry thoroughly before continuing.

## 5. Apply the large wash

Before you begin, prepare two large batches of mixtures of Burnt Sienna and Ultramarine — one rather blue and the other leaning toward brown. Use fresh color right from the tube to get the strength and clarity you'll need. Then, use a large brush to wet the entire background with clear water. Still using a large brush, lay in the predominantly brown mixture, allowing the paint to be darker in some places and lighter in others. When the first wash has dried, repeat the process with the blue mix, again allowing for variations in the color. Repeat until you've achieved this depth of value. Only when these washes are absolutely dry should you peel off the mask.

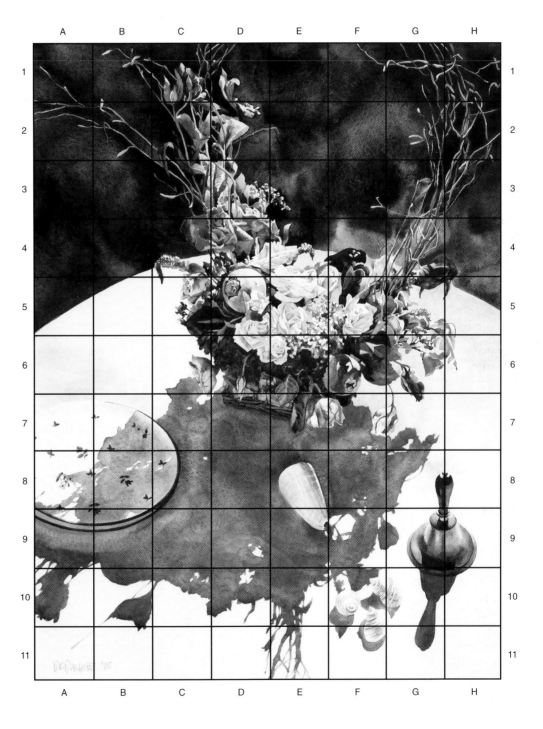

# Put it all together

## 6. Lay in the cast shadows

Using a mixture of Cerulean Blue and Vermilion, apply the cast shadows across the tabletop. Follow the contour of the largest shadow carefully. Remember to put some variations in the values you use, and drop in some Burnt Sienna to suggest reflected light below the plates, bell and shells.

## 7. Define white objects

Apply a very pale wash of Cerulean Blue to the tabletop to the far left, just above the plates, and to the far right behind the basket. While you have this color on your palette, apply a foundation color of pale Cerulean to the white roses.

**Cadmium Red Deep**

**Chinese White + Alizarin Crimson**

## 8. Create the bouquet

Using the two-brush method to work wet-into-wet with small shapes, develop the bouquet. The colors for the various elements are: white roses — Cerulean Blue and Vermilion, with touches of Naples Yellow and Raw Sienna; red flowers — Cadmium Red Deep, with Chinese White and Alizarin Crimson for highlights and Burnt Sienna and Alizarin for shadows; purple flowers — Alizarin Crimson and Phthalo Violet with Cerulean in the shadows; turnips — Naples Yellow, Alizarin Crimson, Phthalo Violet, touches of Raw and Burnt Sienna; light greenery — Cerulean and Lemon Yellow with touches of Sap; darker greenery — Aureolin with Ultramarine and Hookers Green with Ultramarine. While these colors are on your palette, apply them to the painted flowers on the plate.

## 9. Complete the basket and bell

Since both of these items use the same colors, mix up large batches of these colors on your palette before you begin. For the basket, use Raw and Burnt Sienna, with Ultramarine for the shadows of the weave. For the twigs, use Raw Sienna and touches of Cerulean in the shadows and touches of Burnt Sienna for added warmth. The bell will require several glazes over a foundation wash of Raw Sienna. The light blue-gray is Cerulean and Vermilion; the dark gray is Raw Sienna and Ultramarine. Finish with touches of pure Burnt Sienna. For the bell handle, use a near-black mixture of Burnt Sienna and Ultramarine Blue.

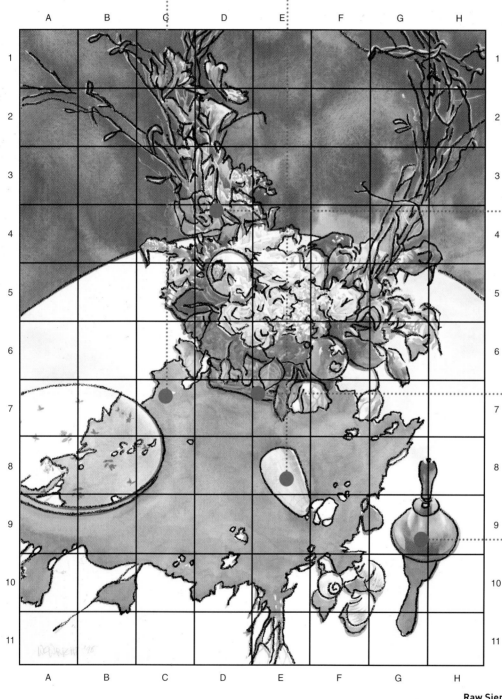

**Raw Sienna + Cerulean**

**Raw Sienna**

**Burnt Sienna and Ultramarine**

## 10. Add the shells

For the larger shell, apply a foundation of Naples Yellow. Shade it with glazes of Cerulean and Vermilion, and detail it with this same gray and Raw Sienna. Use more of these same grays and touches of Naples Yellow for the smaller shells.

**Cerulean + Vermilion**

**Naples Yellow**

## 11. Reinforce the shadow

Your initial wash for the cast shadow probably isn't dark enough, so re-wet the area and apply the same colors used before to reinforce the medium value of this important shape. If needed, you can apply glazes to adjust colors, darken values and refine details.

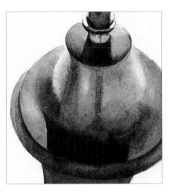

**Detail**

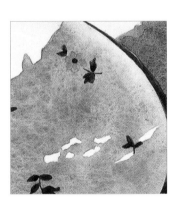

**Detail**

**Detail**

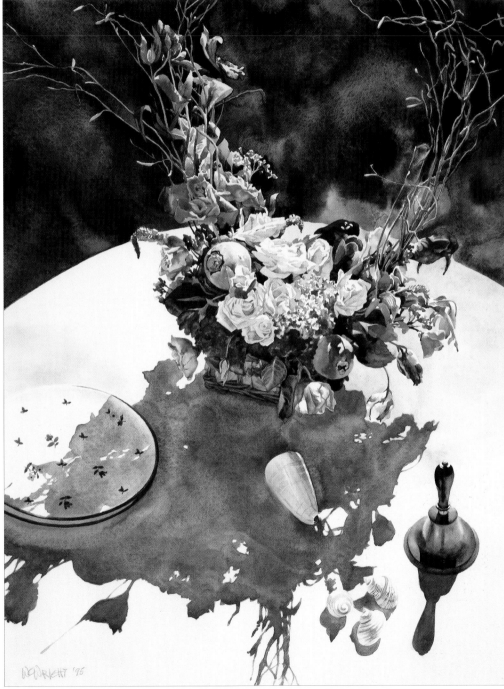

*Basket Bouquet With Bell*, watercolor, 21 x 16" (54 x 41cm) by William C. Wright ©

# art map 9

## Pictures within pictures

Before you begin, read the entire project through so you know what's going to happen next.

I appreciate this particular painting for a number of reasons. For one thing, I always enjoy still lifes that look real, as if you're seeing objects that would naturally be resting together in that place under that light source. This view of our kitchen table, where we typically keep a couple of house plants and also sort our mail, is a great example of an uncontrived arrangement.

Additionally, I've always liked the concept of pictures within pictures, and this still life arrangement afforded several opportunities to include them. Some are obvious — the catalog cover by artist and author Kate Gwynn, as well as the card among the letters. But to me, the porch furniture framed through the kitchen window provides a second, similar element.

As you transfer this drawing to your watercolor paper, let it guide you into thinking about the best strategy for tackling this complex subject. In fact, as you work through all of these projects, look for clues as to the best ways to approach different kinds of paintings. And, as you may have done with several previous projects, feel free to replace the catalog images with your own favorites.

### 1. The image to be transferred using the art map

Read the instructions to see how to map this image across to your paper.

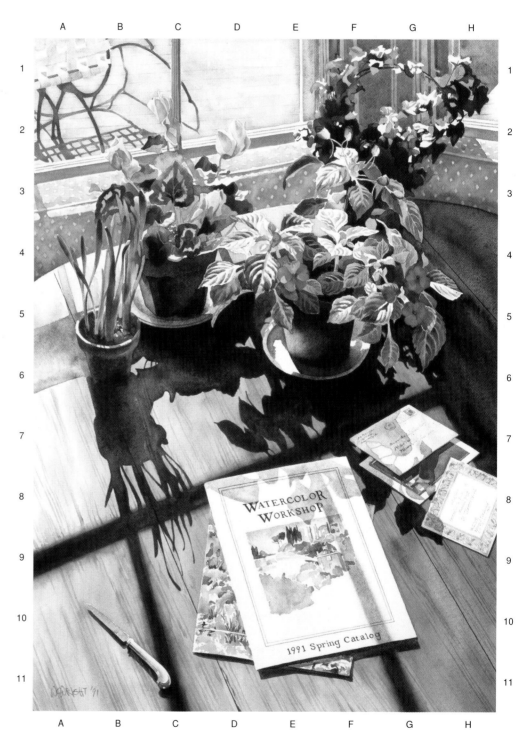

## 2. Mapping the image

First, study how this painting has been divided into a grid. The painting's grid has been evenly divided into 11 horizontal rows and 8 vertical columns. Notice how the grid has been referenced with numbers and letters — just like a map. My painting was 22 x 16" (56 x 41cm), but you can use larger or smaller paper for this exercise, provided your paper is the same proportion as the original painting.

## 3. Use the art map to transfer the image

Now make a corresponding grid on your watercolor paper. Letter and number the grid, using a HB pencil and drawing very lightly. Next, start copying the drawing box by box, referring to the grid reference letters and numbers as needed. Hint: Start by positioning the main shapes first, then lightly add the rest. You don't have to draw every single detail — just get the main shapes down.

**By using this method, you can enlarge or reduce the image to any size you want.**

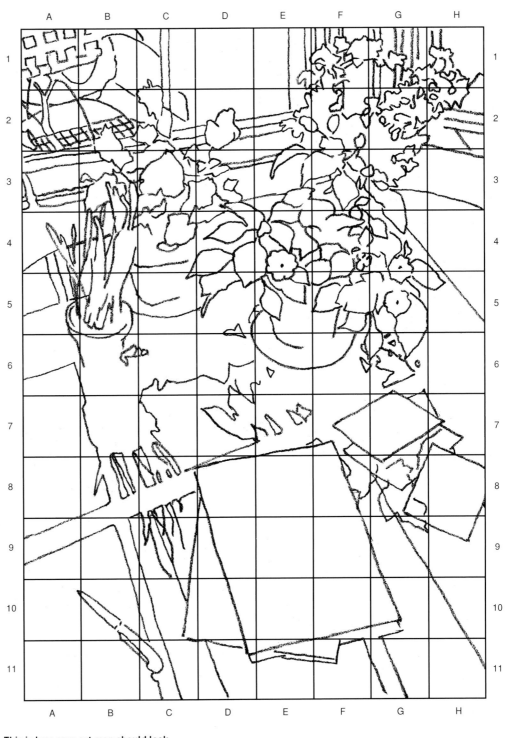

**This is how your art map should look.**
Here I've done the drawing quite heavily so you can see the idea, but you will do this lightly in pencil.

# Study these pages before you start painting

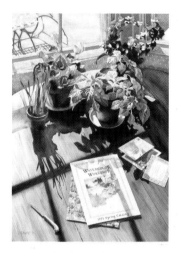

**Focal point guide**
Just by looking at the painting, you can immediately identify the focal point. The red impatiens contain the most extreme contrasts of light against dark and bright against neutral.

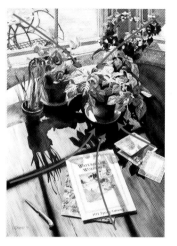

**Movement map**
Notice how shapes — including the shadow shapes — guide your eye into and around the painting. Our eyes tend to follow the path of lighter values first, then travel along the darks in a second pass.

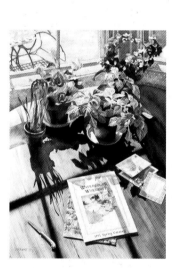

**Tonal value map**
This painting possesses a lot of values at the high (light) and low (dark) end of the value scale. So take care with the values of the plants and yellow seat cushions. These provide the transition between the two extremes.

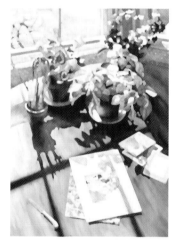

**Color map (squint)**
This version of the painting emphasizes just how warm most of the colors are. It's a good reminder to keep your shadow colors cool for balance.

## materials you'll need

**paper**
140lb (300gsm) hot-pressed or 300lb (638gsm) cold-pressed

**brushes**
nos. 1 through 8 sable rounds

**other tools**
HB pencil

gum eraser

ruler

paper towels

test scrap of same watercolor paper

## your palette for this painting

Aureolin
Cadmium Lemon
Cadmium Yellow Deep
Naples Yellow
Raw Sienna
Burnt Sienna
Cerulean Blue
Ultramarine Blue
Prussian Blue
Vermilion or Bright Red
Cadmium Red Deep
Alizarin Crimson
Opera or Magenta
Phthalo Violet
Sap Green
Hookers Green Dark
Oxide of Chromium
Chinese White

# Consider the following elements

## Light source

Because of the weakness of the winter sun, the light here does not throw the objects into complete silhouette. We can still see the colors and details within the shadows.

## Viewpoint

Just as in Reid's View of My Wall, I used linear elements bleeding off the bottom edge of the painting to invite you into the image.

## Bright idea

My two-brush method is a great way to get soft edges. To achieve them, begin by laying down the stroke of clear water. Then, when you add the stroke of pigment, put the brush down inside the stroke of water, not right on top of it. The pigment will then float gently out toward the edge of the water, creating a soft edge.

## ! Beware

When you're painting something that has a lot of repeated shapes, such as the leaves on the plants, it's easy to paint them all alike. This won't look realistic. Keep in mind that each leaf is individual, and that they grow at different angles and catch the light in different ways. Make the leaves similar but include some variations.

## 4. Lay in the background

To begin, apply a pale wash of Raw Sienna over the porch, window frames and tabletop, working around the purple shadow areas and other objects. Notice how the wash is much lighter on the left. This is just an underpainting. You will darken the values and add details later.

## 5. Put in the cushions

When the initial washes have dried, apply a light base coat of Cadmium Lemon mixed with a touch of Cadmium Yellow Deep to the seat cushions below the windows. Deepen the color as you move into the shadows, working around the pale yellow pattern. When this wash has dried, use Raw Sienna and Burnt Sienna to strengthen the shadowed areas, still working around the lighter yellow dots.

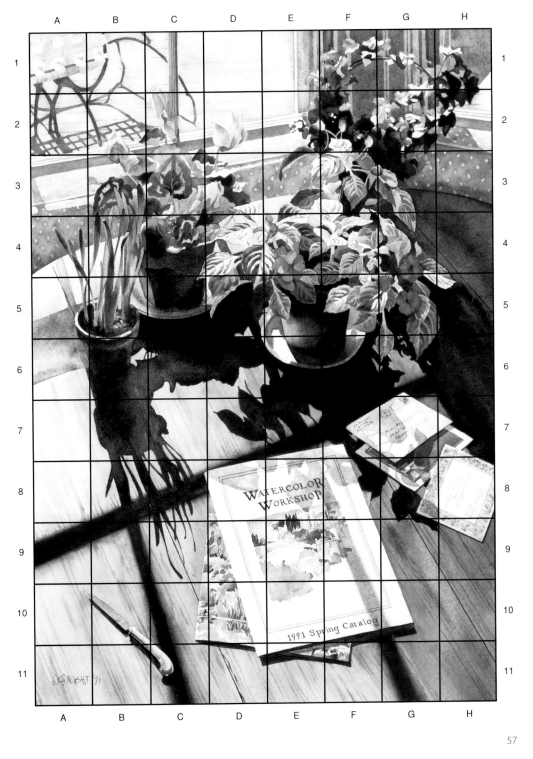

# Put it all together

## 6. Move into the shadows

With the exception of the purple shadows to the left and right of the plants, underpaint all of the cast shadows on the tabletop and under the porch chair with a light wash of Cerulean and Vermilion. When dry, add a second wash of darker Burnt Sienna and Ultramarine, adding touches of Violet as you go along. Repeat as needed to get the desired darkness. Using the two-brush method should keep your edges soft, but you can also soften any hard edges by applying clear water and gently blotting with a paper towel.

## 7. Complement the light

Apply a thin wash of Cerulean mixed with Phthalo Violet to the purple shadow on the left, and use a darker mixture of these two colors for the purple shadow on the right. These shadows can also be strengthened with later glazes.

## 8. Create the plants

First, put in the pink and red flowers. When the flowers have dried, put in all of the leaves and greenery. Work from warm-light to cool-dark, using the color mixes shown in the swatches. Go slowly and carefully define each type of plant.

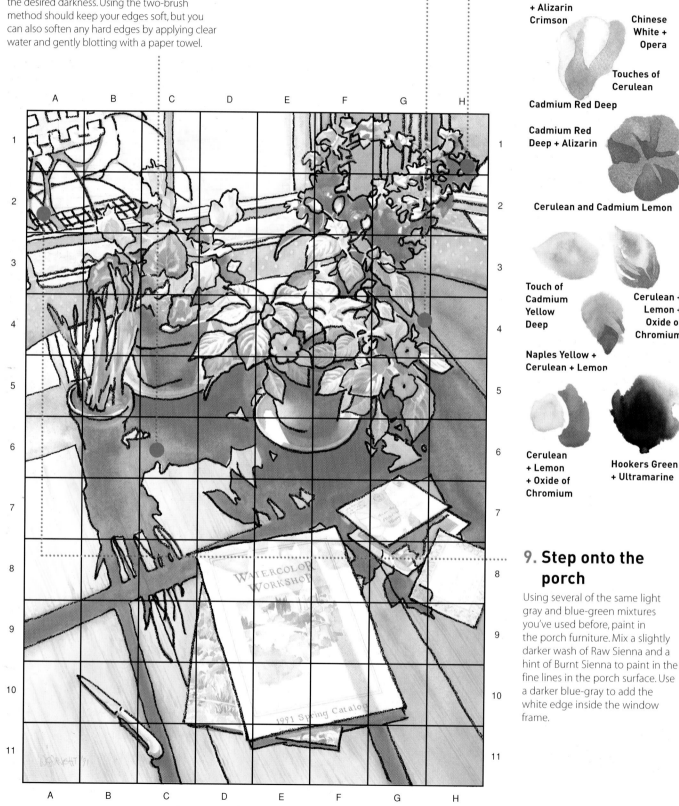

Chinese White + Alizarin Crimson

Chinese White + Opera

Touches of Cerulean

Cadmium Red Deep

Cadmium Red Deep + Alizarin

Cerulean and Cadmium Lemon

Touch of Cadmium Yellow Deep

Cerulean + Lemon + Oxide of Chromium

Naples Yellow + Cerulean + Lemon

Cerulean + Lemon + Oxide of Chromium

Hookers Green + Ultramarine

## 9. Step onto the porch

Using several of the same light gray and blue-green mixtures you've used before, paint in the porch furniture. Mix a slightly darker wash of Raw Sienna and a hint of Burnt Sienna to paint in the fine lines in the porch surface. Use a darker blue-gray to add the white edge inside the window frame.

## 10. Picture this

For color harmony, use many of the same color mixes you've been using to put in the letters and card on the right. The catalog covers can be any images you want — including some you create from your imagination — but I recommend that you keep them lighter in value. Strengthen the light blue cast shadow with a glaze if needed.

## 11. Refine the background

Mix up of various strengths of Raw Sienna, Burnt Sienna and Ultramarine to apply glazes over the window frames, cushions, cast shadows and tabletop as needed to match the values in my original. Use dark mixtures to put in the grain of the wood. Add more glazes if needed to adjust colors, darken values or enhance details.

**Detail**

**Detail**

**Detail**

**Detail**

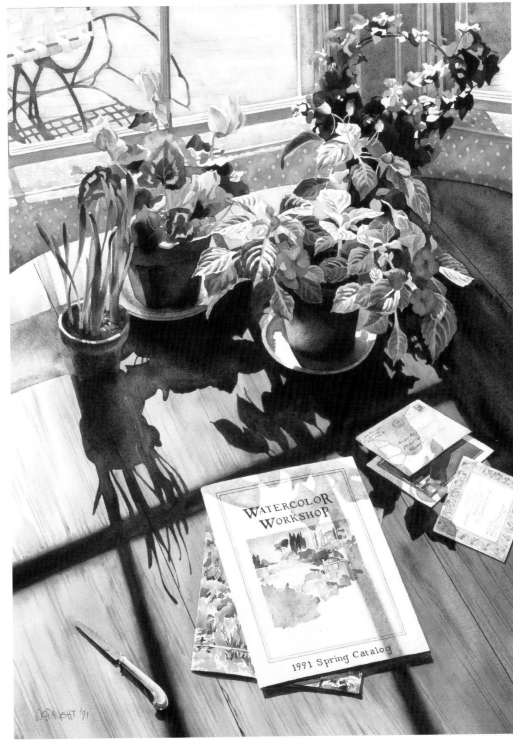

*Waiting for Spring*, watercolor, 22 x 16" (56 x 41cm) by William C. Wright ©

# art map 10
## Something new

Before you begin, read the entire project through so you know what's going to happen next.

Every once in a while, we all need to push ourselves to try something new in our paintings. With this work, I decided to challenge myself to come up with an interesting and colorful composition without using flowers. My solution was to incorporate the fairly intense green table — it provided a way of bringing in brighter color. For me, striving for something different refreshes my sense of creativity and adventure.

Although the various objects in the painting are borrowed from a number of different people, I like the way they work together to suggest a story about a fictitious person. A storytelling quality in art tends to get viewers involved by encouraging them to wonder what — or who — the painting is about.

As you prepare to recreate this painting, you may want to make sure you have plenty of smaller brushes on hand. There are several very small shapes with plenty of detail. They'll be a challenge to paint, but they'll be rewarding to do, too.

## 1. The image to be transferred using the art map

Read the instructions to see how to map this image across to your paper.

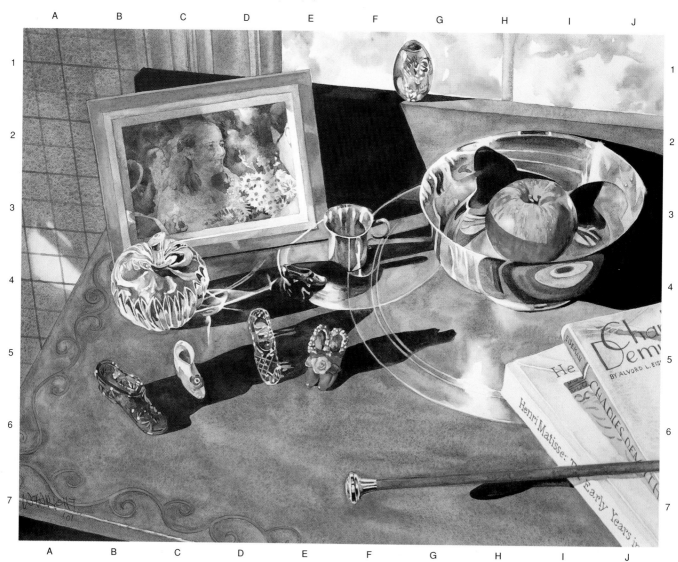

## 2. Mapping the image

First, study how this painting has been divided into a grid. The painting's grid has been evenly divided into 7 horizontal rows and 10 vertical columns. Notice how the grid has been referenced with numbers and letters — just like a map. My painting was 12 x 16" (31 x 41cm), but you may want to use something proportionally larger to give yourself more space.

**By using this method, you can enlarge or reduce the image to any size you want.**

## 3. Use the art map to transfer the image

Now make a corresponding grid on your watercolor paper. Letter and number the grid, using a HB pencil and drawing very lightly. Next, start copying the drawing box by box, referring to the grid reference letters and numbers as needed. Hint: Start by positioning the main shapes first, then lightly add the rest. You don't have to draw every single detail — just get the main shapes down.

**This is how your art map should look.**

Here I've done the drawing quite heavily so you can see the idea, but you will do this lightly in pencil.

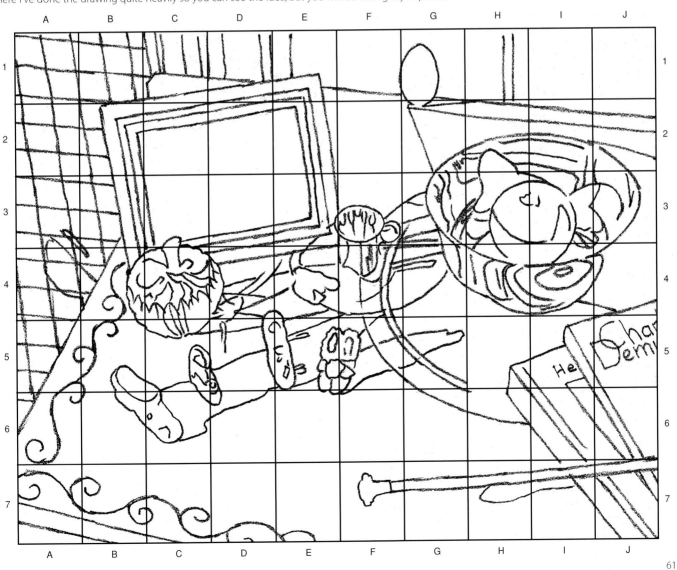

# Study these pages before you start painting

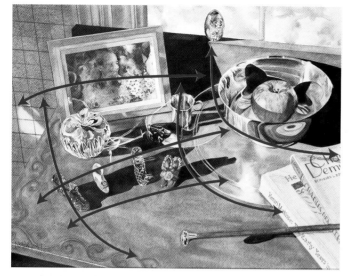

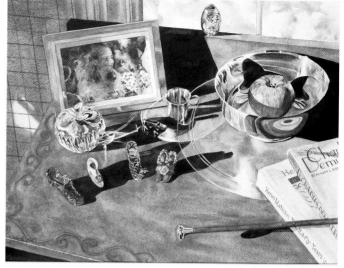

## Shape map
At first glance, this arrangement seems simple but it's actually fairly complicated. The objects on the left tend to align one way, while the objects on the right align the opposite way. This subtle form of contrast offers greater interest for the viewer.

## Tonal value map
What is the purpose of the very dark green shadows at the top and bottom of the painting? These are like visual stop signs, preventing your eye from leaving the image.

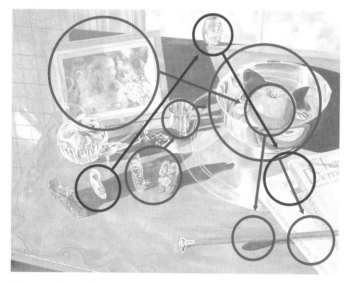

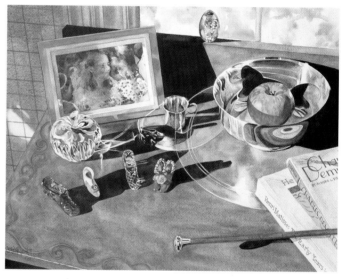

## Color map (squint)
If you focus your eyes on just the bright, repeated colors, you'll notice how they create patterns that echo the movement of the shapes — leading you back on the left, forward on the right.

## Barrier blueprint
In effect, the egg and the wooden stick serve the same purpose as the dark shadows, don't they? Use your finger to cover these objects one at a time. Without them, your eye could drift right out of the painting.

## materials you'll need

**paper**
140lb (300gsm) hot-pressed or 300lb (638gsm) cold-pressed

**brushes**
nos. 1 through 8 sable rounds

**other tools**
HB pencil
gum eraser
ruler
paper towels
test scrap of same watercolor paper

## your palette for this painting

Aureolin
Cadmium Lemon
Cadmium Yellow Deep
Naples Yellow
Raw Sienna
Burnt Sienna
Cerulean Blue
Ultramarine Blue
Prussian Blue

Vermilion or Bright Red
Cadmium Red Deep
Alizarin Crimson
Opera or Magenta
Phthalo Violet
Sap Green
Hookers Green Dark
Oxide of Chromium
Chinese White

# Consider the following elements

## Light source

This is tricky — there are actually two light sources here. The main light source comes from behind the viewer's left shoulder, but a supplementary light source comes from the window.

## Viewpoint

I particularly enjoy looking down into curved, reflective objects, like this silver bowl and cup. The refracted, abstracted shapes add so much interest to the objects.

## Beware

A large shape that's all one color, such as this green tabletop, can look dull and boring if it's treated exactly the same way throughout. Always include some subtle variations in the color and value to make a large shape more interesting.

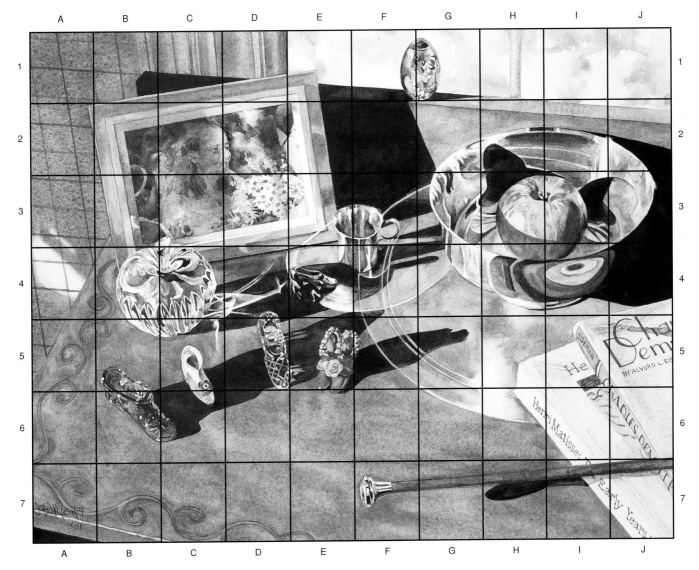

## 4. Cover the main shape

Begin by mixing up a very large batch of Cerulean Blue, Cadmium Lemon and a little Raw Sienna. Using a smaller brush, apply the neutral green over the entire tabletop, working carefully around the red inlaid design. (If you're not comfortable with this, you can mask off the design, paint over it, then remove the masking when the wash is dry.) To get the soft-edged white halo surrounding the silver bowl, apply the clear water first and let the green float into the water. Be sure to put in the green tabletop appearing within the glass apple and reflected in the silver bowl.

**Cerulean Blue + Cadmium Lemon + Raw Sienna**

## 5. Get the objects going

Using the Cerulean-Vermilion gray mix, lay a pale wash on the wall behind the table, the window frame, the photograph, the silver objects and the glass apple. Keep this underpainting wash light and work around the whites.

# Put it all together

## 6. Put in the shadows

Next, mix a large batch of Cerulean Blue, Cadmium Lemon, Hookers Green and Ultramarine. Your mixture should be a middle value. Apply a single coat of this darker blue-green to the cast shadows behind all of the objects, skipping over the white haloes, and to the shadow below the table's edge. When the first wash has dried, add a second coat over the larger, darker shadows. If they aren't dark enough yet, you can always glaze over them again.

## 7. See the reds

Since red is sprinkled throughout, paint all of the reds at one time, using variations of the same general colors. Start with Raw Sienna alone and mixed with Burnt Sienna, and paint in the picture frame and the wooden stick. For the apple, apply an underpainting wash of Raw Sienna and Cadmium Yellow Deep, then use Cadmium Red Deep and Alizarin Crimson for the

redder streaks and markings. Use Burnt Sienna and Ultramarine for the apple's shadowed side. Use a mixture of Vermilion and Cadmium Red Deep for the design on the table.

**Cadmium Red Deep**

**Raw Sienna +
Cadmium Yellow Deep**

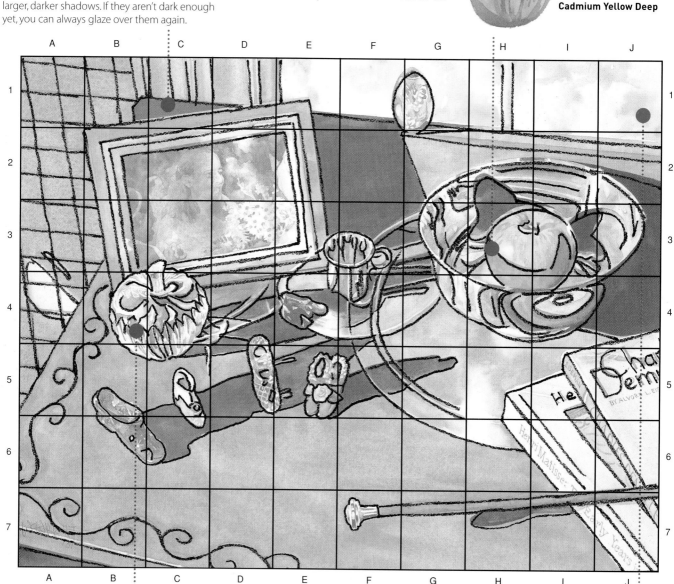

## 8. Turn to the silvers

Grays also appear repeatedly so approach all of these areas in one pass, too. To paint the black-and-white photograph, mix a light gray and a dark gray, then mix the two together to get a medium gray, as shown in the swatches. Enhance the grays in the glass apple if needed, then add the other reflected colors as shown. Layer on more medium grays in the silver cup, bowl and wooden-stick tip, following the curves and reflections as you see in my original. Drop in some reflected greens and reds as the grays are drying to get soft edges. Glaze on darker grays as needed.

**Cerulean + Vermilion**

**Ultramarine +
Burnt Sienna**

**Cerulean + Vermilion + Ultramarine
+ Burnt Sienna**

## 9. Wash the windows

The greenery beyond the window requires just a simple wet-into-wet wash, dropping in some Naples Yellow, Cerulean and Phthalo Violet into the clear water. Tilt the board to make the pigment flow through the water in a loose, free pattern. Let dry thoroughly before continuing.

## 10. Bring on the color

With most of the neutral objects completed, it's time to have some fun with the bright colors and details of the objects. You can follow my original, but if you'd prefer to use your own color scheme, remember to repeat colors to unify the painting. The colors I used are: green shoe — Sap Green and Cerulean Blue in the light side, Hookers Green and Ultramarine for the darks; pink shoe — Chinese White and Alizarin Crimson, plus Cerulean in the shadows; blue shoe — Cerulean and Ultramarine; red shoes — Vermilion and Aureolin, plus Cadmium Red Deep in the shadows. Notice how the red, pink and blue all appear in the red shoes' details. Similarly, the egg contains Phthalo Violet and the grays and blue-greens used earlier, and then all of these colors are repeated in the book covers.

## 11. Perfect the image

Finally, add the pattern to the wall with a medium-value mix of Cerulean and Ultramarine, then define the woodwork with more pale gray glazes. Compare your painting to my original. You can always add more glazes as needed to refine the image.

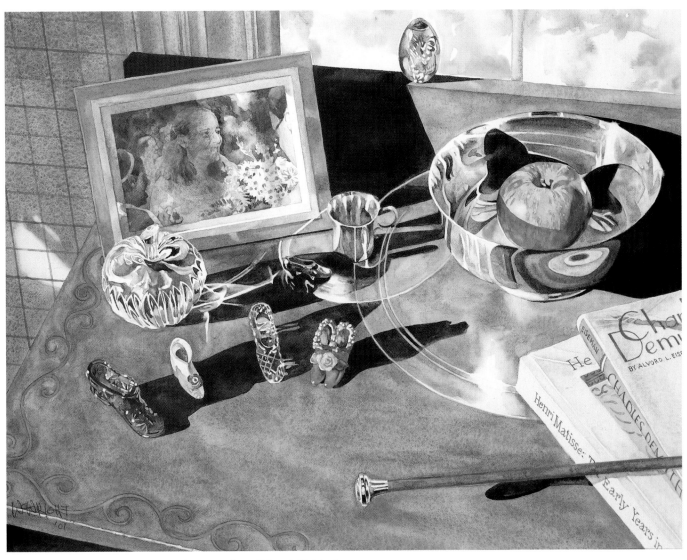

*Apples and Shoes*, watercolor, 12 x 16" (31 x 41cm) by William C. Wright ©

**Detail**

**Detail**

**Detail**

# art map 11

## Bright color complements

Before you begin, read the entire project through so you know what's going to happen next.

Every summer, a local flower and vegetable grower sets up a little produce stand near my house. All season long, I buy flowers from her to use for my students' still life arrangements as well as my own. On this occasion, I was knocked out by the vibrant colors of all the different flower types — Indian paintbrush, zinnia, dahlia and more. I decided to create something really dramatic around these gorgeous blooms.

First, I chose a 40 x 30" (102 x 76cm) sheet of watercolor paper, which is probably one of the largest paintings I've ever done. I decided to make the objects slightly larger than life size for added punch. And then I went straight to one of my favorite tools — the contrast of opposite colors — to grab your attention. I combined the warm tones of the flowers with a brightly painted ceramic pitcher, then offset these hot colors with cool blues. Even the simple, dark background is energized with blues and oranges. What impact!

Painting such a large piece is not easy, so you may want to scale down to a smaller 4:3 ratio. And don't worry about matching every detail of my piece. Just make sure you accurately match the perspective of the bowls, ceramic pitcher and table. Once again, I recommend using masking fluid before doing the dark, juicy background.

## 1. The image to be transferred using the art map

Read the instructions to see how to map this image across to your paper.

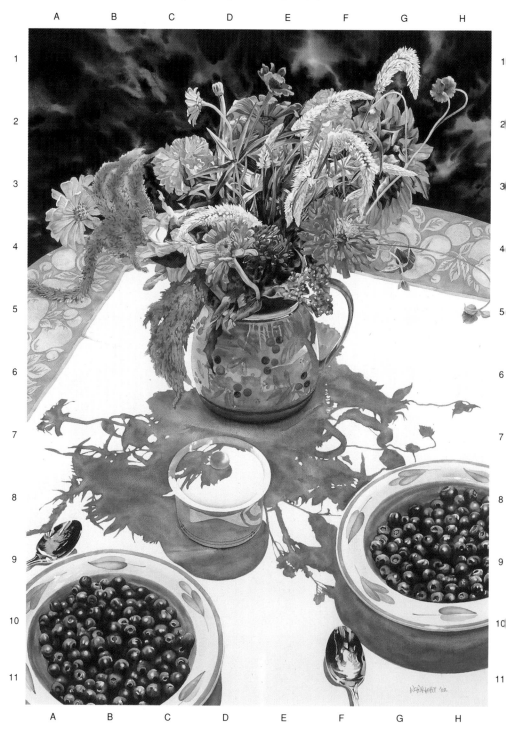

## 2. Mapping the image

First, study how this painting has been divided into a grid. The painting's grid has been evenly divided into 11 horizontal rows and 8 vertical columns. Notice how the grid has been referenced with numbers and letters — just like a map. My painting was 40 x 30" (102 x 76cm), but I suggest scaling down to something proportionally smaller.

## 3. Use the art map to transfer the image

Now make a corresponding grid on your watercolor paper. Letter and number the grid, using a HB pencil and drawing very lightly. Next, start copying the drawing box by box, referring to the grid reference letters and numbers as needed. Hint: Start by positioning the main shapes first, then lightly add the rest. You don't have to draw every single detail — especially not all the greenery nor the pattern in the tablecloth — just get the main shapes down.

**By using this method, you can enlarge or reduce the image to any size you want.**

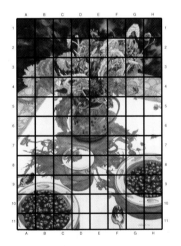

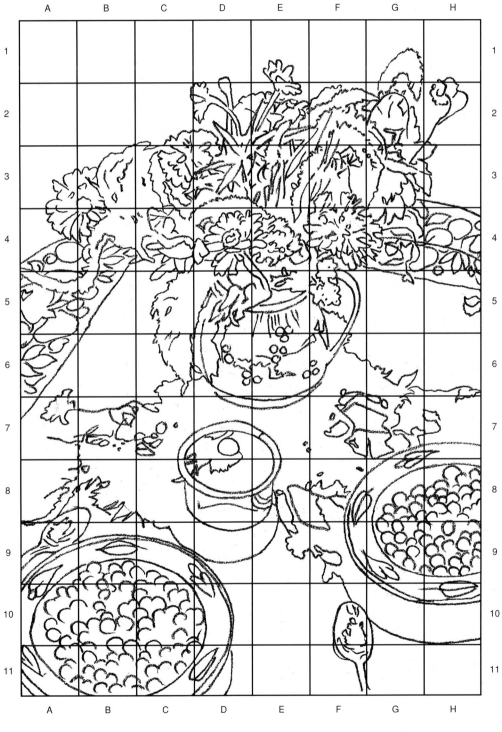

**This is how your art map should look.**
Here I've done the drawing quite heavily so you can see the idea, but you will do this lightly in pencil.

# Study these pages before you start painting

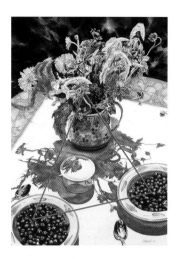

**Shape map**
Here, the three main objects align in a triangular shape, which is a classic design for a still life.

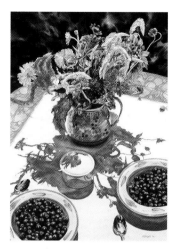

**Tonal value map**
When you squint at the painting, you see that the three brightest areas of color are quite similar in value. Again, this reinforces that triangular foundation.

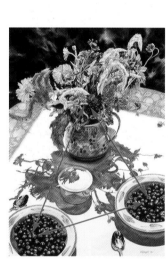

**Movement map**
Because the flowers and two bowls of blueberries are so equal in size, weight and intensity, your eye bounces from one to the next, constantly moving around the painting.

**Color map (squint)**
This is a great way to study the contrasts of the colors and color temperatures — the hot oranges and reds against the cool blues. This is an attention-getting color scheme.

## materials you'll need

**paper**
140lb (300gsm) hot-pressed or 300lb (638gsm) cold-pressed

**brushes**
nos. 1 through 8 sable rounds

**other tools**
HB pencil

gum eraser

ruler

paper towels

test scrap of same watercolor paper

masking fluid

rubber cement pick-up

## your palette for this painting

Aureolin
Cadmium Lemon
Cadmium Yellow Deep
Naples Yellow
Raw Sienna
Burnt Sienna
Cerulean Blue
Ultramarine Blue
Prussian Blue

Vermilion or Bright Red
Cadmium Red Deep
Alizarin Crimson
Opera or Magenta
Phthalo Violet
Sap Green
Hookers Green Dark
Oxide of Chromium
Chinese White

# Consider the following elements

## Light source

Here, the backlighting is coming from the right. As is often the case, the cast shadow created by this strong light source is integral to the unity of the design.

## Viewpoint

Positioning my vantage point here meant that I could see light falling on the sugar bowl. This white shape breaks up the big shadow shape in an interesting way.

## Beware

I agree that it's a lot of fun to paint textured or detailed objects, but you have to be careful about going too far. Always put the most detail in the focal point — in this case, the flowers. Other secondary, less important areas, such as the blueberries, the tablecloth and the background, should have decreasing levels of detail as you move away from the focal area.

## 4. Mask around the background

Use an old, worn brush to apply liquid masking fluid to all of the elements touching the background. Notice the little spots of dark peeping through the floral arrangement, and work around them. Allow the fluid to dry thoroughly before continuing.

## 5. Apply the large wash

Before you begin, prepare several large batches of paint mixtures: Burnt Sienna with some Ultramarine; Ultramarine with some Burnt Sienna; Hookers Green and Ultramarine; Raw Sienna and Burnt Sienna; and Chinese White and Alizarin Crimson. Turn your board upside down and use a large brush to wet the entire background with clear water. Still using a large brush, lay in the lighter mixtures in a random pattern similar to mine and fill in with the darker blue. When the first wash has dried, repeat the process with the darker mixtures, again working around the lighter colors. Repeat until you've achieved this depth of value. Only when these washes are absolutely dry should you peel off the mask.

## 6. Paint the red paintbrushes

To get the feathery look of the Indian paintbrush flowers, turn your board on its side. Then wet the paper with clear water and drop in pure Cadmium Red Deep. Use the same approach for the red zinnia on the right.

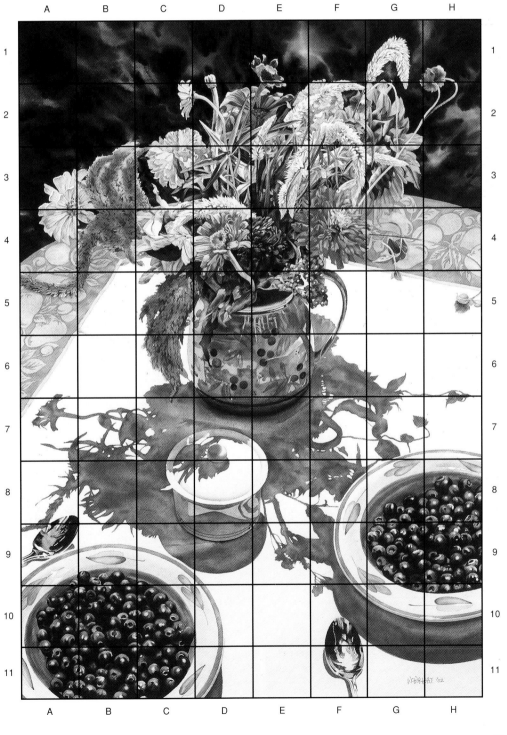

# Put it all together

## 7. Lay in pale washes

After the red wash has dried, mix up a large quantity of light Cerulean and Vermilion. Apply it wet-into-wet over the white Indian paintbrushes. Then lay the underpainting wash over all of the cast shadows, taking the wash right over the shadowed front of the sugar bowl.

## 8. Add the yellows and siennas

Next, mix up Cadmium Yellow Deep with Raw Sienna to apply an undercoat to the ceramic pitcher. When that has dried, apply a mixture of Raw Sienna with Burnt Sienna to glaze on the darker shadowed areas. For the sunflowers and zinnias, apply a base coat of Cadmium Lemon mixed with Cadmium Yellow Deep. When dry, glaze on the darker shadowed areas of these flowers with pure Cadmium Yellow Deep, pure Raw Sienna, a mix of Cerulean Blue and Cadmium Lemon or the Cerulean and Vermilion gray.

## 9. Complete the bouquet

Working slowly and allowing each area to dry thoroughly before adding more glazes, finish developing all of the flowers and greenery. The colors used are: off-white zinnia — Naples Yellow and Chinese White with a touch of Cerulean Blue, and touches of Oxide of Chromium in the shadows; background red zinnia — Cadmium Yellow Deep at the tips, then Alizarin Crimson mixed with Cadmium Red Deep and touches of Burnt Sienna in the shadows; pink zinnia — Chinese White and Alizarin Crimson, with touches of Opera and Cerulean in the shadows; purple dahlia — Phthalo Violet and Alizarin Crimson with Cerulean highlights and Prussian Blue shadows; and tiny pink flowers — Alizarin with Phthalo Violet. The greens are all made from various combinations of yellows, tube greens and blues, with touches of Raw Sienna here and there. Finally, add the details on the pitcher.

## 10. Put in the blueberries

Before you clean off your palette, use some of the same flower colors to put in the design on the bowls. For the rims, use a light mix of Cerulean and Ultramarine. Over the berries and the bowls' interiors, lay a pale wash of Cerulean mixed with Prussian Blue, working around the white highlights. When the wash has dried, use pure Prussian to define the overlapping shapes of the berries. When that has dried, apply a final glaze of dark Ultramarine and Burnt Sienna for the darkest shadows. Before you finish, use glazes of these blues and gray-blue mixes, including the dark shadow color, to build up the silverware.

**Cerulean Blue + Prussian Blue**

**Overlaid with Ultramarine + Burnt Sienna**

**Overlaid with Prussian**

## 11. Pattern the tablecloth

If you haven't already, draw in the fruit pattern of the blue part of the tablecloth. Lay a light, wet-into-wet wash of Cerulean Blue over the entire area. When the wash has dried, apply a darker mix of Cerulean and Ultramarine to create the pattern. To simplify this area, you could simply paint a wet-into-wet wash of mingled Cerulean and Ultramarine.

## 12. Finish with the cast shadow

Using a mixture of Cerulean and Vermilion and a separate mixture of Ultramarine and Burnt Sienna, apply a glaze over the cast shadow area. Notice the value and color variations throughout, especially how these subtleties define the shape of the sugar bowl. While the wash is still wet, drop in some Burnt Sienna to warm up dark areas. You may need to glaze on a few more details or washes to complete the painting.

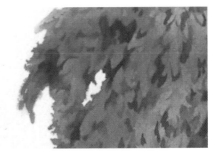

**Detail**

**Detail**

**Detail**

**Detail**

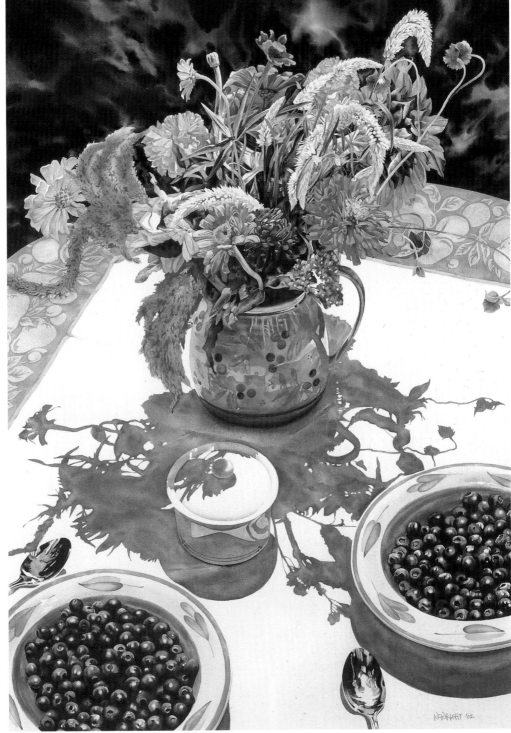

*Paintbrushes, Dahlias and Blueberries*, watercolor, 40 x 30" (102 x 76cm) by William C. Wright ©

# art map 12

## Simplicity at its finest

Before you begin, read the entire project through so you know what's going to happen next.

This painting is deceptively simple, but that's part of its appeal. It's the kind of instantly recognizable subject that immediately connects with viewers, taking them back to all of their favorite summer memories.

When you look closer, you'll see that I've used all of my most sophisticated tools to lend excitement to this humble subject.

Try to identify them for yourself. You'll find the contrast of bright against white, dark against light, active against passive, and yes, even red with its complementary green.

Although it may appear to be easy, this will provide you with great practice in making objects look three-dimensional and real. The refracted cast shadow is also a

workout for mastering soft edges. Excellent brush skills are required when you get this close to objects because it's essential to be accurate and precise and to maintain control of your values. If you particularly enjoy recreating this painting, I recommend you try the same idea with other fruits and vegetables in interesting containers.

## 1. The image to be transferred using the art map

Read the instructions to see how to map this image across to your paper.

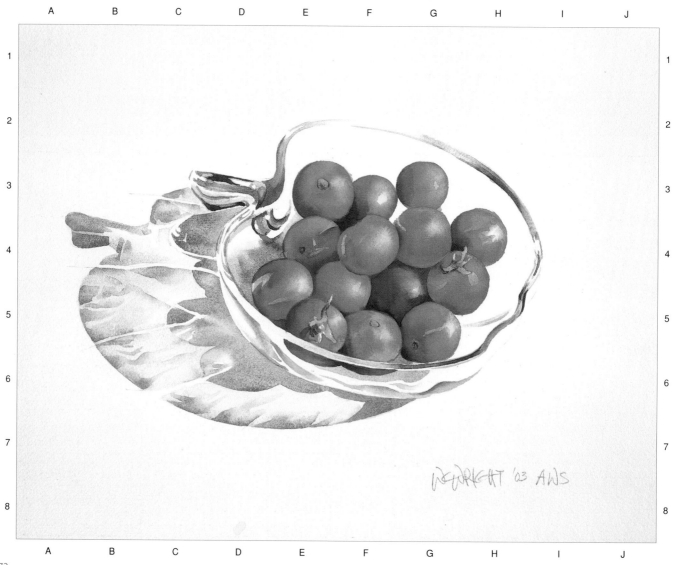

## 2. Mapping the image

First, study how this painting has been divided into a grid. The painting's grid has been evenly divided into 8 horizontal rows and 10 vertical columns. Notice how the grid has been referenced with numbers and letters — just like a map. My painting was 9 ½ x 11" (24 x 28cm), which is probably just right for this simple subject.

## 3. Use the art map to transfer the image

Now make a corresponding grid on your watercolor paper. Letter and number the grid, using a HB pencil and drawing very lightly. Next, start copying the drawing box by box, referring to the grid reference letters and numbers as needed. Hint: Start by positioning the main shapes first, then lightly add the rest. You don't have to draw every single detail — just get the main shapes down.

**By using this method, you can enlarge or reduce the image to any size you want.**

**This is how your art map should look.**

Here I've done the drawing quite heavily so you can see the idea, but you will do this lightly in pencil.

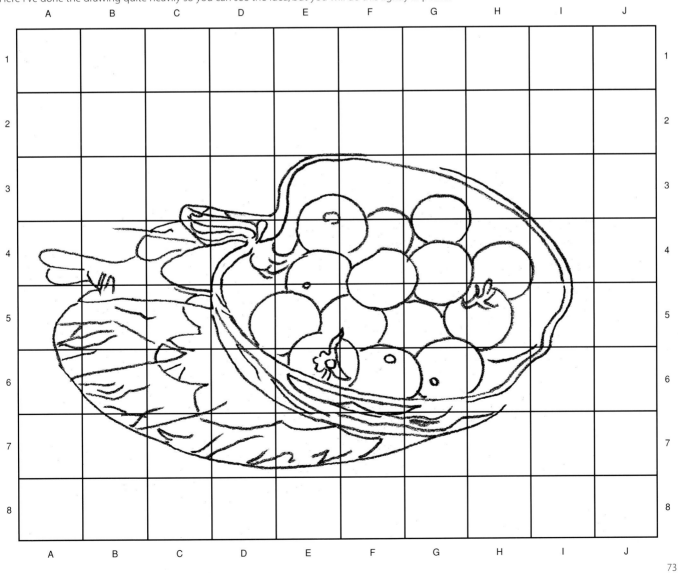

# Study these pages before you start painting

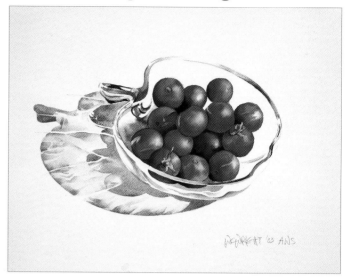

**Shape map**

I can't emphasize this enough — variety is key in painting. Look at the exciting contour of the overall shape of the tomatoes. Then notice the differences among the shapes within that shape. Especially when you're this close to a subject, interesting shapes are vitally important.

**Tonal value map**

The tomatoes create a highly concentrated mass of bright color in a darker value. I cropped this image quite carefully to provide enough light value to balance the intensity of that shape.

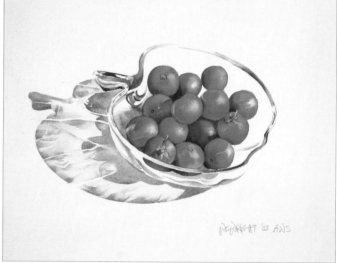

**Edge guide**

Make sure you keep using the two-brush method so you can control your edges. Float the pigment into a light stroke of water to create a soft edge; lay juicy pigment right over a generous stroke of water for a hard edge.

**Color map (squint)**

There is no question that red is our dominant color here. So what's the perfect color to balance it out? Its complement — green — of course. The cool blue-grays also offset the warmth of the reds.

## materials you'll need

**paper**
140lb (300gsm) hot-pressed or
300lb (638gsm) cold-pressed

**brushes**
nos. 1 through 8 sable rounds

**other tools**
HB pencil
gum eraser
ruler
paper towels
test scrap of same watercolor paper

## your palette for this painting

Aureolin
Cadmium Lemon
Cadmium Yellow Deep
Naples Yellow
Raw Sienna
Burnt Sienna
Cerulean Blue
Ultramarine Blue
Prussian Blue

Vermilion or Bright Red
Cadmium Red Deep
Alizarin Crimson
Opera or Magenta
Phthalo Violet
Sap Green
Hookers Green Dark
Oxide of Chromium
Chinese White

# Consider the following elements

### Light source

A bright light from the upper right makes the all-white background believable while casting a beautiful shadow to the left.

### Viewpoint

This angle shows off the eye-catching contour of the apple dish as well as the variety of tomato shapes.

### Bright idea

When you're painting a subject as simplified as this, you need to make every shape special. Look at this cast shadow, for example. It reads as one large shape, but it's actually filled with interesting sub-shapes and variations. It makes the painting come alive.

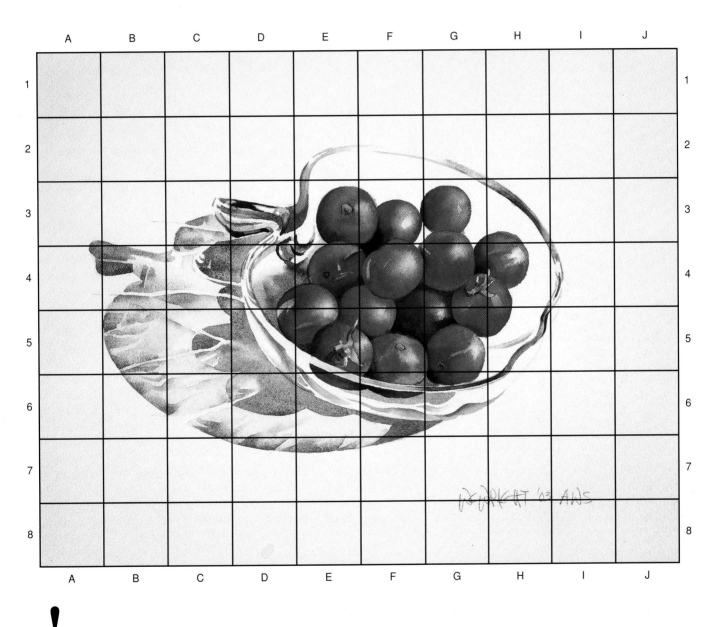

## ! Beware

When painting and glazing around white or light highlights, it's all too easy to create hard edges. You want to keep these transitions of color soft and natural. If you accidentally get a too-hard edge, soften it with clear water and a soft brush, and then blot the excess liquid and pigment with a paper towel.

## 4. Define the contours

Using a pale wash of Cerulean mixed with Vermilion, define the outer contours of the cast shadow and the lip of the apple-shaped bowl. This is just a very light wash to start with.

# Put it all together

## 5. Plant the tomatoes

To begin, apply a light wash of Vermilion over each tomato, one at a time. Apply the washes to alternating tomatoes so that the pigment does not bleed. If you need to lift out a highlight, dampen the pigment with clear water and a soft brush, then blot with a paper towel. When that wash has dried, go back and apply a Vermilion wash over all of the tomatoes in between. Let that dry thoroughly before continuing.

## 6. Round out the reds

In the next series of glazes, you will start to define the three-dimensional roundness of each tomato. Use the two-brush method to get soft edges as you apply Cadmium Orange to some of the top sides near the highlights and Cadmium Red Deep to move into the shadows. Continue to lift out the highlights as needed.

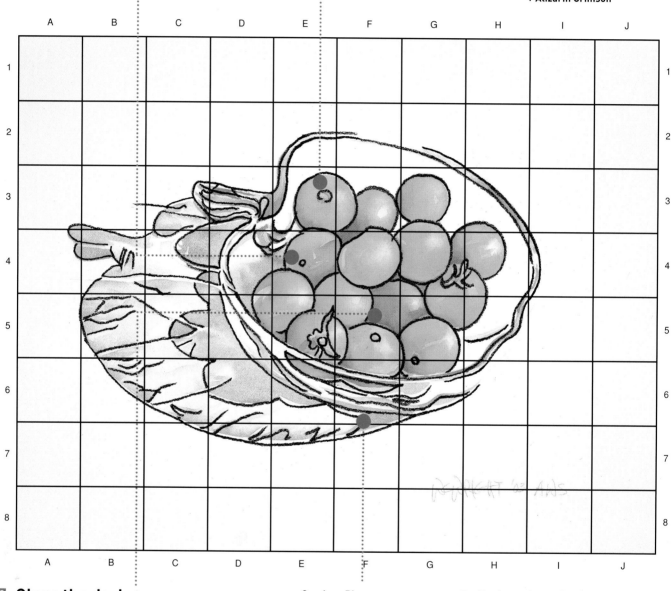

**Vermilion**

**Cadmium Red Deep**

**Cadmium Orange**

**Cadmium Red Deep**

**Cadmium Red Deep + Alizarin Crimson**

## 7. Glaze the darks

Some tomatoes will need yet another glaze of Alizarin Crimson and Cadmium Red Deep for darker shadows. The darkest shadows of all are glazed with a mixture of Ultramarine Blue and Burnt Sienna.

**Cerulean Blue + Vermilion**

**Cerulean Blue + Vermilion + Ultramarine + Burnt Sienna**

## 8. Paint the shadow

Next, mix up a darker gray by combining the Cerulean and Vermilion with Ultramarine Blue and Burnt Sienna. Use your test sheet to determine whether you have the right value and temperature of this gray. Continue to use the two-brush method so you can control the soft and hard edges of each shadow shape within the overall cast shadow of the bowl. When this layer has dried, add a hint of Vermilion to your gray to glaze on the cast shadow of the tomatoes.

# 9. Finish the details

The clear glass bowl is defined by small shapes of color around the rim as well as some shadows. Darken the gray shadow shapes with glazes as needed. Then glaze on shapes of green, black, red and Raw Sienna as seen in my original. Use Sap Green to complete the few stems on the tomatoes.

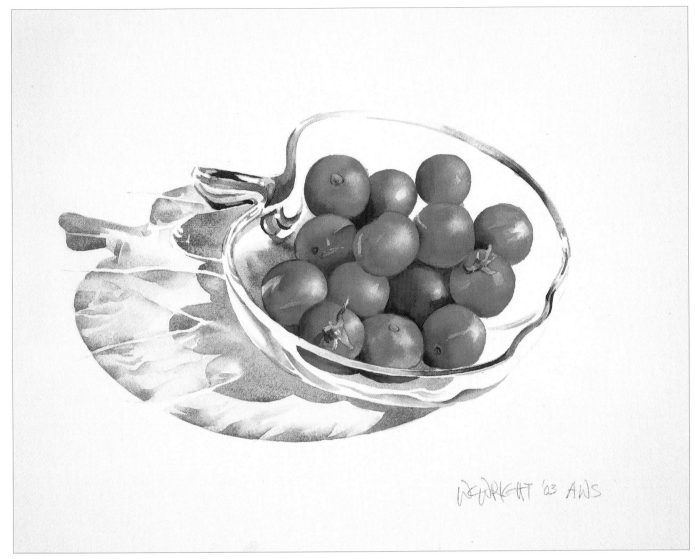

*Cherry Tomatoes*, watercolor, 9½ x 11" (24 x 28cm) by William C. Wright ©

**Detail**

**Detail**

**Detail**

# art map 13

## Clean and fresh

Before you begin, read the entire project through so you know what's going to happen next.

Late in the summer, our neighbors' blackberry patch takes off, producing plenty of sweet fruit for everyone to enjoy. Not only are they great to eat, they're fun to paint! For this still life, I simply added some flowers from our garden, brought some dishes from the kitchen and let the bright summer sun work its magic.

Inspired by the rich blue of the berries, I decided to go for a classic color combination: the three primaries. I brought in the straw place mats for their dull yellow and picked primarily red flowers for the bouquet. Together with the white, these dominant colors make the whole painting look fresh, clean and lively.

The place mats may present a bit of a challenge to paint. They're extremely detailed with countless fine lines, requiring a steady hand. If you wish, you can simplify these mats into basic circular shapes. Or you can lightly suggest some texture by putting in subtle variations in the color or value.

### 1. The image to be transferred using the art map

Read the instructions to see how to map this image across to your paper.

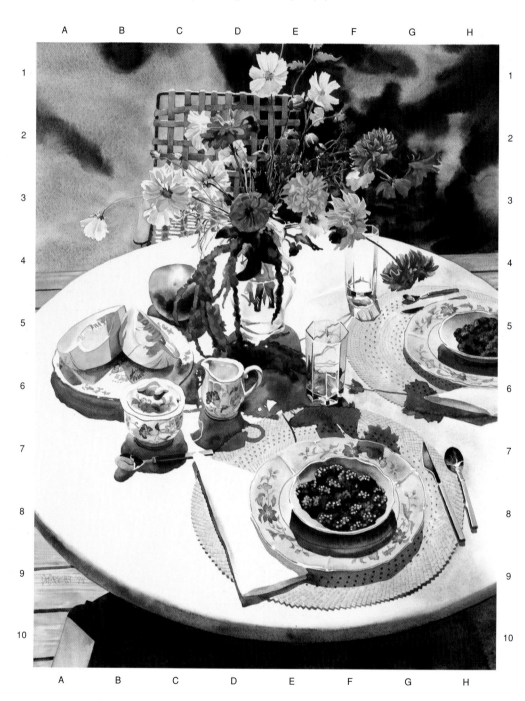

## 2. Mapping the image

First, study how this painting has been divided into a grid. The painting's grid has been evenly divided into 10 horizontal rows and 8 vertical columns. Notice how the grid has been referenced with numbers and letters — just like a map. My painting was 21 x 16" (54 x 41cm), but you can use larger or smaller paper for this exercise, provided your paper is the same proportion as the original painting.

## 3. Use the art map to transfer the image

Now make a corresponding grid on your watercolor paper. Letter and number the grid, using a HB pencil and drawing very lightly. Next, start copying the drawing box by box, referring to the grid reference letters and numbers as needed. Hint: Start by positioning the main shapes first, then lightly add the rest. You don't have to draw every single detail — just get the main shapes down.

**This is how your art map should look.**
Here I've done the drawing quite heavily so you can see the idea, but you will do this lightly in pencil.

**By using this method, you can enlarge or reduce the image to any size you want.**

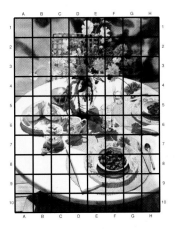

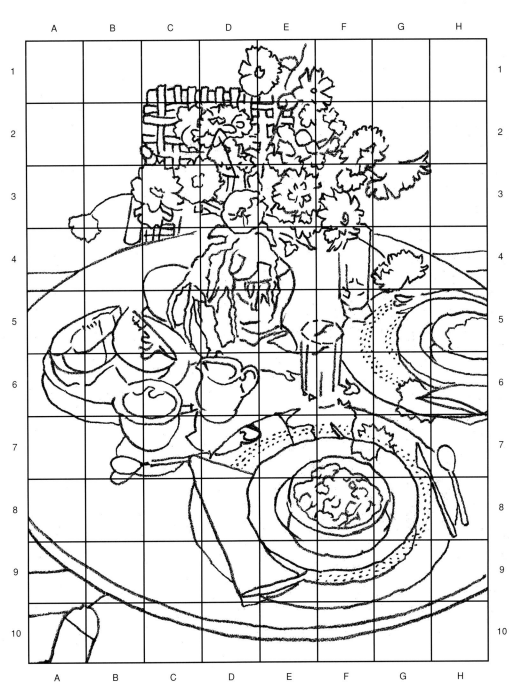

# Study these pages before you start painting

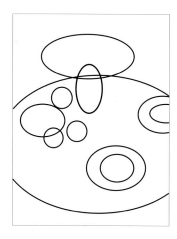

**Shape map**
Plenty of overlapping, circular shapes keep your eye swirling around this image.

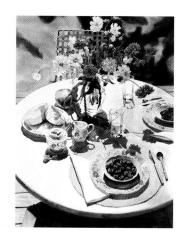

**Tonal value map**
Take note of the depth of the dark values shown here. As always, you will need several glazes to get this level of intensity.

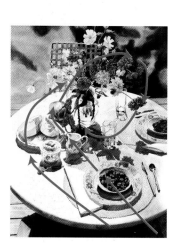

**Movement map**
To me, the dark shapes have all the power in this picture. They align to guide your eye in a spiraling pattern around the painting.

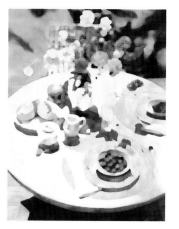

**Color map (squint)**
Viewed this way, you can really see the three primaries standing out. However, I think using dulled-down versions of the red and yellow along with a dark blue keeps the color scheme from looking too obvious or cute.

## materials you'll need

**paper**
140lb (300gsm) hot-pressed or 300lb (638gsm) cold-pressed

**brushes**
nos. 1 through 8 sable rounds

**other tools**
HB pencil

gum eraser

ruler

paper towels

test scrap of same watercolor paper

## your palette for this painting

Aureolin
Cadmium Lemon
Cadmium Yellow Deep
Naples Yellow
Raw Sienna
Burnt Sienna
Cerulean Blue
Ultramarine Blue
Prussian Blue
Phthalo Green

Vermilion or Bright Red
Cadmium Red Deep
Alizarin Crimson
Opera or Magenta
Phthalo Violet
Sap Green
Hookers Green Dark
Oxide of Chromium
Chinese White

# Consider the following elements

### Light source
The summer sun was high in the sky, toward the back left. Because of large trees overhead (not shown in the painting), a few slight shadows appear on the right side of the table.

### Viewpoint
That bowl of berries right in the front is so inviting, isn't it? Wouldn't you like to sit down and share the meal?

### Bright idea
You don't always need to paint every detail of every object in your arrangement. Quite often, showing some detail in just one part of an object is enough to clue the viewer into its texture or design. So consider putting in just some of the detail in one or two small areas of the place mats, and let your viewer's imagination fill in the rest.

!

### Beware
In my experience, it's hard to judge the true value of the initial washes until I begin to establish the values of the other elements around it for comparison. That's why I usually start light and darken the values as needed in the final stages when I can see the overall value pattern coming together.

### 4. Mask around the background
Use an old, worn brush to apply liquid masking fluid to all of the elements touching the background. Notice the little shapes of background color peeking through the chair and floral arrangement and work around them. Allow the fluid to dry thoroughly before continuing.

### 5. Wash the background
Before you begin, prepare several large batches of light gray (Cerulean and Vermilion) and dark gray (Ultramarine and Burnt Sienna). Turn your board upside down and use a large brush to wet the entire background with clear water. Still using a large brush, lay in the light gray, varying it by adding more and less water. While it's still wet, lay in the darkest mixture, allowing it to intermingle with the light gray to create medium gray transitions. Only when these washes are absolutely dry should you peel off the mask.

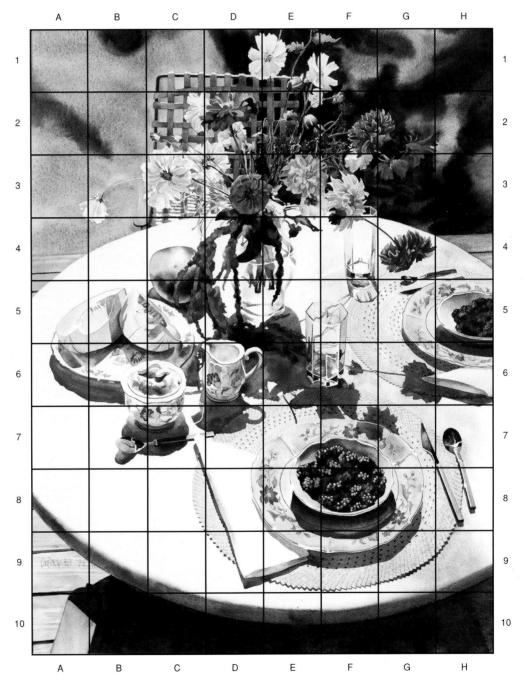

# Put it all together

## 6. Apply a base coat

Many of the objects have pale gray shadows, so mix up a large batch of Cerulean and Vermilion. Apply light washes of this color to the white cosmos, vase, china, glasses, napkins, silverware, cast shadows and pale shadow on the lower right of the tabletop. Keep your edges soft.

## 7. Build up the bouquet

By now, you've had plenty of experience using foundation colors and glazes to paint flowers and greenery. As always, remember to work around the whites. Use bright, intense colors from your palette, adding Chinese White if needed for pale colors and cool Alizarin Crimson or Cerulean for the shadowed sides of the blooms.

## 8. Add the fruit

Use the same technique to create the various fruits. The colors used are: cantaloupe — Naples Yellow with touches of Cadmium Lemon and Cadmium Yellow Deep, with Raw Sienna, Vermilion and Cerulean in the shadows; cantaloupe rind — Naples Yellow with a touch of Cerulean; papaya — Cadmium Red Deep flowing into Aureolin, blending into a mix of Aureolin and Cerulean; blackberries — Cerulean Blue and Prussian Blue. To lift out the highlights on the berries, use a small, soft brush and clear water to gently soften the pigment, then blot with a paper towel.

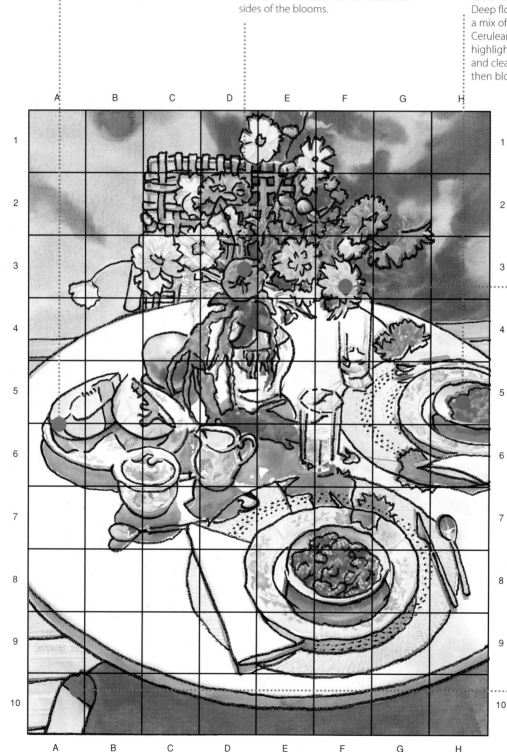

## 9. Bring in dull yellows

Use the same basic color combinations for the place mats and for the deck below the table. Begin with a foundation wash of watered-down Naples Yellow. Leave as is if you want to keep it simple, or paint in the woven pattern with darker Naples Yellow mixed with touches of Raw Sienna and Cerulean. For the cast shadow that defines the edge of the place mat, use a combination of Naples Yellow, Vermilion and Cerulean. Use the same light color mix for the wood grain in the deck and the same dark mix for the shadows between the boards. Glaze Cerulean over the two back portions of the deck to push those into the distance.

## 10. Pull up the chairs

For the arm rests of the chairs (one front and one back), use Phthalo Green mixed with some Cerulean Blue. Then create two more batches of this mixture, adding Ultramarine to one and Burnt Sienna to the other. Use these color combinations to paint the variations in the plastic webbing of the chair seat.

## 11. Define the dishes

Mix up various values of Cerulean and Vermilion, and apply them as needed to further define the shapes of the dishes, glasses, napkins and silverware. Apply a darker blue-gray glaze to enhance all of the cast shadows, adding warm Raw Sienna under the edges of the dishes. Notice that the biggest cast shadow below the bouquet has hints of reflected colors, such as Violet and Raw Sienna. Use light variations of the flower and fruit colors to paint in the design on the china.

## 12. Refine your painting

Finally, compare your painting to my original, especially in terms of the values. If the background or the shadow below the table aren't dark enough, apply a mixture of Ultramarine and Burnt Sienna. Apply additional glazes as needed to darken values, adjust colors and enhance details.

**Detail**

**Detail**

**Detail**

**Detail**

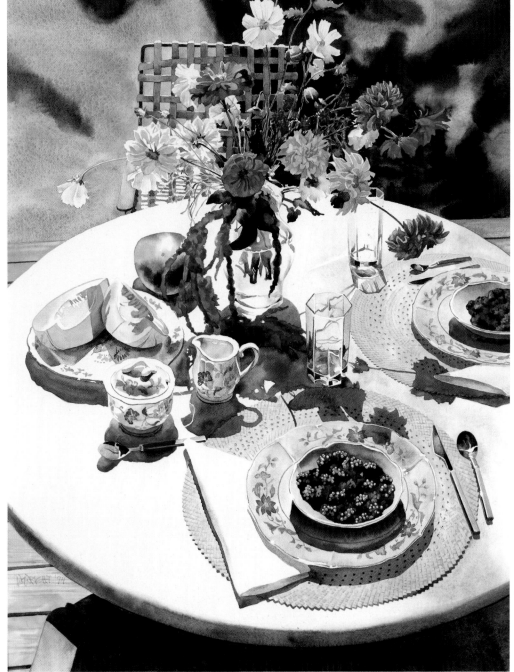

*Blackberries With Cosmos*, watercolor, 21 x 16" (54 x 41cm) by William C. Wright ©

# art map 14

## A delicate balance

**Before you begin, read the entire project through so you know what's going to happen next.**

This painting is part of a series of irises. I couldn't resist their colorful, abstract shapes popping up among the blue-green sword leaves. For me, painting in a series is a great way to learn your subject and create images that look good together, sometimes showing a progression in time or life cycle.

Even in my small paintings, I use many of the same techniques for grabbing a viewer's attention. Notice the complementary color scheme, the cool tones offsetting the warm tones, the full range of tonal values, the variety of shapes and the differences between hard and soft edges.

I painted this on a smooth, hot-pressed surface. I prefer this surface for small works because I love the way the paint floats on the surface. Plus, you can see how the paper shows off the granulating effect of this Cerulean Blue, adding yet another type of contrast — texture against flat.

It is harder to control the paint on a hot-pressed surface, but you can lift out paint more easily because the paint does not absorb as much into the paper. Keep in mind that you can only layer about three coats of paint before you start disturbing the lower layers and making muddy colors.

### 1. The image to be transferred using the art map

Read the instructions to see how to map this image across to your paper.

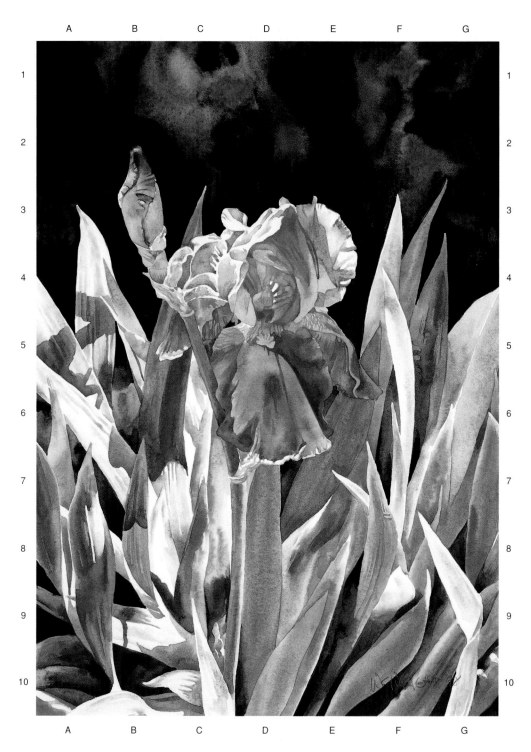

## 2. Mapping the image

First, study how this painting has been divided into a grid. The painting's grid has been evenly divided into 10 horizontal rows and 7 vertical columns. Notice how the grid has been referenced with numbers and letters — just like a map. My painting was 12 x 10" (31 x 26cm), but you can use larger or smaller paper for this exercise, provided your paper is the same proportion as the original painting.

## 3. Use the art map to transfer the image

Now make a corresponding grid on your watercolor paper. Letter and number the grid, using a HB pencil and drawing very lightly. Next, start copying the drawing box by box, referring to the grid reference letters and numbers as needed. Hint: Start by positioning the main shapes first, then lightly add the rest. You don't have to draw every single detail — just get the main shapes down.

**This is how your art map should look.**
Here I've done the drawing quite heavily so you can see the idea, but you will do this lightly in pencil.

**By using this method, you can enlarge or reduce the image to any size you want.**

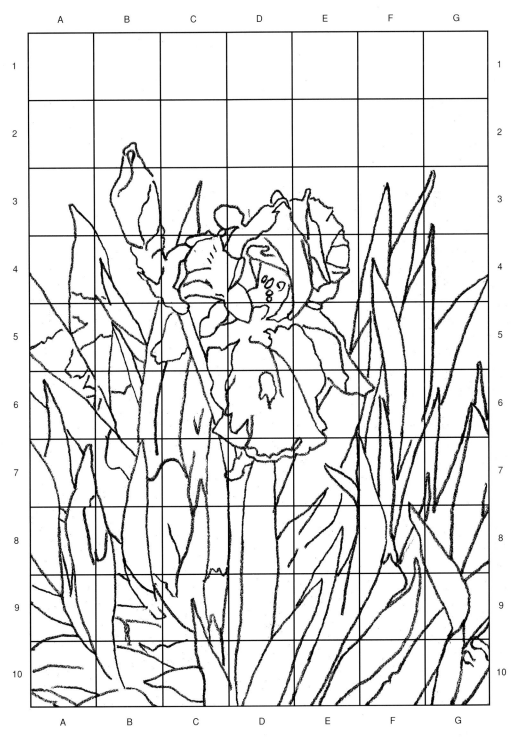

# Study these pages before you start painting

**Shape map**
This design balances a medium-size, simple shape with both smaller and larger active shapes. To me, the leaves read as one shape because of their color, although there are plenty of varied sub-shapes within it.

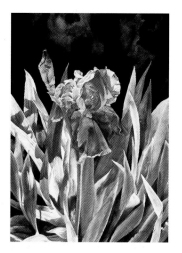

**Tonal value map**
Notice how the small pockets of shadows across the bottom anchor the image and balance that heavy background shape at the top.

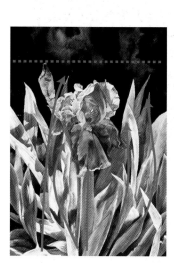

**Movement map**
The distinctly vertical leaves pull your eye straight up in the painting, but the intricacy of the flower and the extreme tonal contrasts around it retain your eye and prevent you from exiting through the top edge.

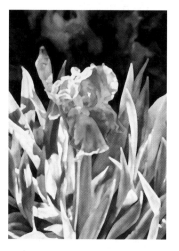

**Color map (squint)**
One of the things that makes this painting so visually exciting is the alternating pattern of cool and warm colors.

## materials you'll need

**paper**
140lb (300gsm) hot-pressed or 300lb (638gsm) cold-pressed

**brushes**
nos. 1 through 8 sable rounds

**other tools**
HB pencil

gum eraser

ruler

paper towels

test scrap of same watercolor paper

## your palette for this painting

Aureolin
Cadmium Lemon
Cadmium Yellow Deep
Naples Yellow
Raw Sienna
Burnt Sienna
Cerulean Blue
Ultramarine Blue
Prussian Blue

Vermilion or Bright Red
Cadmium Red Deep
Alizarin Crimson
Opera or Magenta
Phthalo Violet
Sap Green
Hookers Green Dark
Oxide of Chromium
Chinese White

# Consider the following elements

## Light source

Here, a very bright light is beaming down from overhead, just a little to the left. Notice how the intensity of the light bleaches the color from the leaves and petals directly facing the light source.

## Viewpoint

I wanted the flower to be somewhat centered, but a strange optical illusion would have occurred if I had placed it in the true center. It would have appeared to be lower than center. Therefore, I had to position it a little above center so that the overall leaf mass could balance the upper background shape.

## Bright idea

Some pigments — such as Cerulean Blue — are known as sedimentary colors because you can see the grains of pigment settling in the washes when they dry. Experiment with your favorite palette colors to find other sedimentary pigments. Then use them when you want to create instant texture in a wash.

## ! Beware

Have you ever created a painting that looked a little dull? Chances are good you didn't include enough different values. If you want excitement, try to use nearly a full range of values from black to white.

## 4. Lay the flower's foundation

To begin, apply a light mixture of Cadmium Yellow Deep and Raw Sienna over the yellow portions of the iris. Keep the edges soft where the color will transition into red. When the yellow wash has dried, apply a light wash of Cadmium Red Deep mixed with Alizarin Crimson. Again, soften the transitions wherever the red meets the yellow. Let dry completely before continuing.

**Cadmium Yellow Deep + Raw Sienna**

**Cadmium Red Deep + Alizarin Crimson**

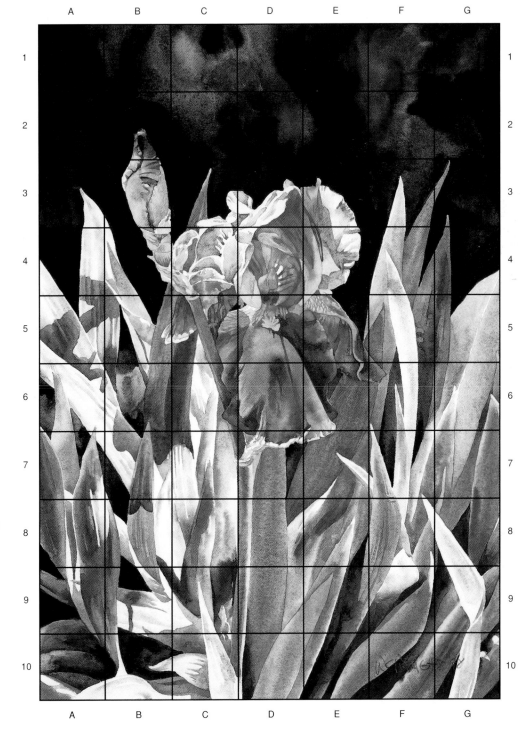

# Put it all together

## 5. Define the iris form

Follow my original to understand the petals' curves and ruffled edges. For the shadow glaze on the yellow areas, mix Raw Sienna, Burnt Sienna and a touch of Ultramarine to create a lively gray. While painting this color, add touches of pure Cerulean Blue to accent the edges. The lighter red shadows are done with pure Alizarin Crimson, and the darker red shadows are done with Alizarin mixed with Ultramarine. While these are still wet, drop in touches of Alizarin and Phthalo Violet.

## 6. Wash in the leaves

Before you begin, mix up large quantities of two different combinations of Cadmium Lemon and Cerulean Blue — one that leans toward yellow and the other more blue. Wet the lightest areas first and lay in light washes of the two colors, tilting the board to make the pigments flow through the water. Continue to work wet-into-wet as you apply darker versions of the same colors elsewhere in the underpainting, leaving the hidden background areas untouched. Skip around, alternating leaves so that you always have a dry edge to paint up against. Pay close attention to your light source.

**Cadmium Lemon + Cerulean Blue**

**Cerulean Blue + Cadmium Lemon**

**Cadmium Lemon + Cerulean + Ultramarine**

**Aureolin + Cerulean + Ultramarine**

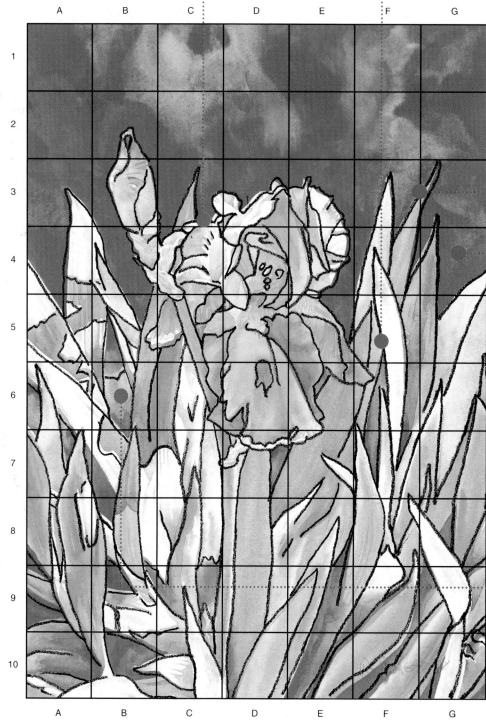

## 7. Develop the greenery

When the initial layers of green have dried completely, glaze on the shadow colors. Mix both cool and warm greens as shown in the swatches, and use them together and separately. Combine Hookers Green and Ultramarine for the darkest shadow areas.

## 8. Dive into the background

Before you begin, mix up several large quantities of some dark colors: pure Burnt Sienna, Ultramarine Blue mixed with Burnt Sienna and Ultramarine mixed with Hookers Green. Then, turn your board upside down. Working quickly but carefully, apply clear water along the upper edges of the leaves, iris and bud. Immediately wet the rest of the background shape as well. Use strong saturated color and quickly lay in random strokes of your colors, allowing the colors to freely merge. When the first wash has dried, repeat the application. Continue to repeat until you've reached a satisfactory depth of color.

## 9. Complete the background

At this point, you should have only a few open spots tucked in among the leaves on the right. Layer on Burnt Sienna in these areas to help connect the top of the painting with the lower half.

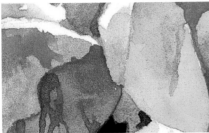

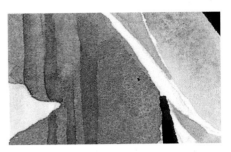

Detail

Detail

Detail

Detail

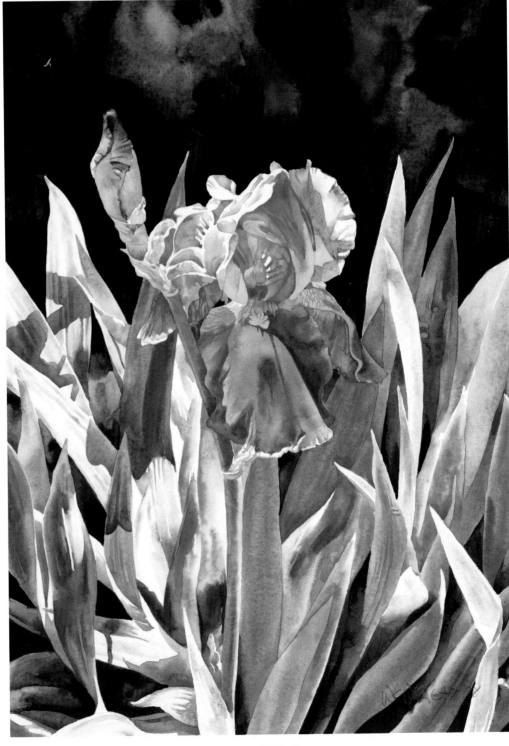

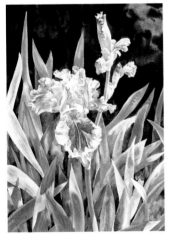

Here's another painting from
the iris series —
*Iris (Early Celebration)*,
watercolor, 14 x 10" (36 x 26cm).

*Red Iris*, watercolor, 12 x 10" (31 x 26cm) by William C. Wright ©

# art map 15

## Intriguing textures

Some years ago, my wife and I rented a cottage in the Loire Valley in France. I didn't know what I was going to paint when we got there, but I ended up painting a variety of landscape and architectural scenes. I found endless sources of inspiration.

I particularly like this painting because it's a landscape but it has the feel of a still life. The pots of flowers, the brick wall, the bright blue gate and the dappled stone walk combine to tell the story of this French country home and its residents. I know you're going to enjoy using the bright colors to recreate the textures and patterns of the various elements. As always, accurate drawing is the hardest part, but I've provided the Art Map for you.

During that entire summer in France, I worked en plein air, and I've been recommending this practice to artists ever since. By working outdoors on location, I learned to see the true colors of nature and to mix them on my palette. Plein-air painting is an invaluable experience for all artists.

Before you begin, read the entire project through so you know what's going to happen next.

### 1. The image to be transferred using the art map

Read the instructions to see how to map this image across to your paper.

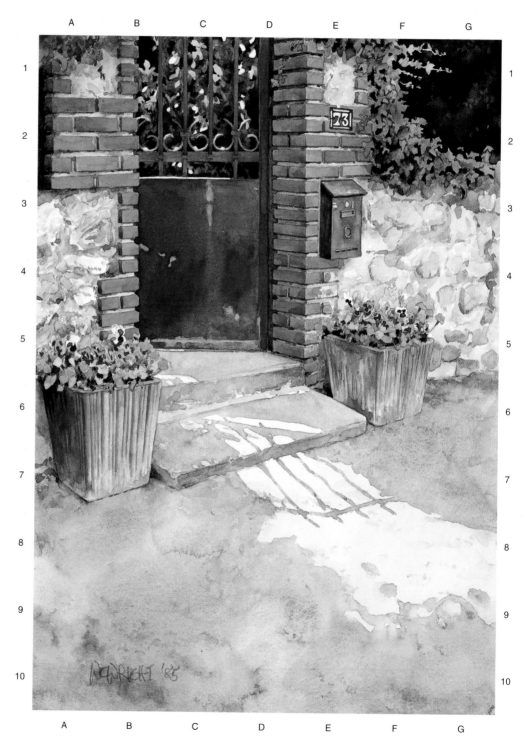

## 2. Mapping the image

First, study how this painting has been divided into a grid. The painting's grid has been evenly divided into 10 horizontal rows and 7 vertical columns. Notice how the grid has been referenced with numbers and letters — just like a map. My painting was 14 x 10" (34 x 26cm), but you can use larger or smaller paper for this exercise, provided your paper is the same proportion as the original painting.

## 3. Use the art map to transfer the image

Now make a corresponding grid on your watercolor paper. Letter and number the grid, using a HB pencil and drawing very lightly. Next, start copying the drawing box by box, referring to the grid reference letters and numbers as needed. Hint: Start by positioning the main shapes first, then lightly add the rest. You don't have to draw every single detail — just get the main shapes down.

**This is how your art map should look.**

Here I've done the drawing quite heavily so you can see the idea, but you will do this lightly in pencil.

**By using this method, you can enlarge or reduce the image to any size you want.**

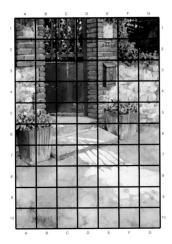

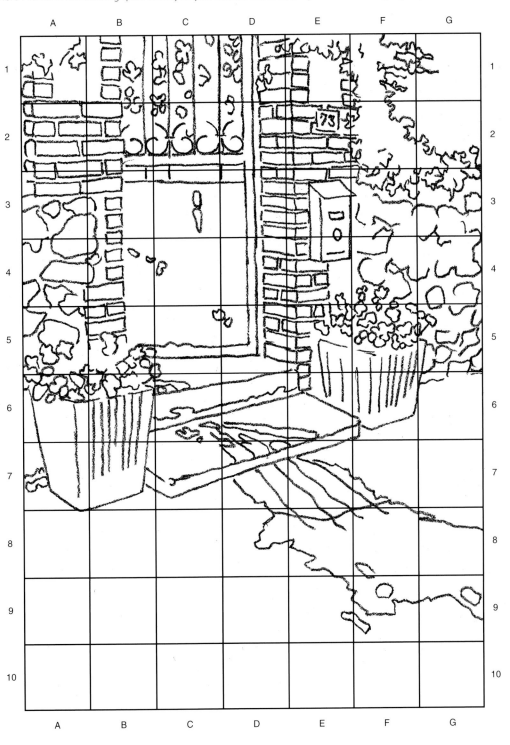

# Study these pages before you start painting

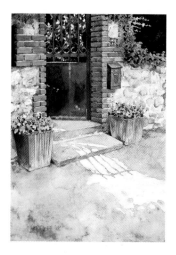

**Tonal value map**
This painting contains predominantly mid-values, with some dark areas and light areas flowing through the center.

**Balance blueprint**
Here's another great example of passive areas offsetting active areas. Most often, activity needs to be concentrated in a smaller area and requires a larger area of inactivity to balance it out.

Active area

Passive area

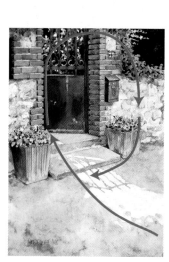

**Movement map**
Here, the light areas are the elements sweeping your eye into the subject and up and around the painting.

**Color map (squint)**
This shows how important the blue passages in the foreground are. They're needed to anchor the blues and other intense colors above.

## materials you'll need

**paper**
140lb (300gsm) hot-pressed or 300lb (638gsm) cold-pressed

**brushes**
nos. 1 through 8 sable rounds

**other tools**
HB pencil

gum eraser

ruler

paper towels

test scrap of same watercolor paper

## your palette for this painting

Aureolin
Cadmium Lemon
Cadmium Yellow Deep
Naples Yellow
Raw Sienna
Burnt Sienna
Cerulean Blue
Ultramarine Blue
Prussian Blue
Phthalo Green

Vermilion or Bright Red
Cadmium Red Deep
Alizarin Crimson
Opera or Magenta
Phthalo Violet
Sap Green
Hookers Green Dark
Oxide of Chromium
Chinese White

# Consider the following elements

## Light source

The soft, afternoon light here was bright enough to cast great shadows and light up some of the transparent leaves, but not strong enough to throw everything in the foreground into dark, shadowed silhouette.

## Viewpoint

What does cropping the gate below its top edge do for you? I felt it enhanced the allure of the painting by drawing your attention to the gate and making you wonder what lies beyond.

## Bright idea

When I recommend repeating the same colors, don't assume they have to be the exact same colors. You can take a mixture that you've already used and modify it slightly before you use it somewhere else. Repeating similar colors will lend more variety to a painting but will still harmonize the color scheme.

## 4. Lay in light washes

Before you begin, mix up very large quantities of the various pale cream colors found in much of the painting. First, dilute some pure Naples Yellow with a lot of water. In another well, mix a light blue-gray of Cerulean and Vermilion. Then, gradually add the gray to the Naples Yellow a little at a time. If it turns too green, add Vermilion. If it turns too pink, add more Cerulean. In yet another well, dilute some Chinese White. Add some of the cream to the white. Apply this pale cream as a foundation over the rock walls, the brick walls (notice the mortar color) and the stone walkway and steps. Save the remaining paint mixes for later.

**Naples Yellow**
**+ Cerulean**
**+ Vermilion**

**Base mixture**
**+ Chinese White**
**+ touch of Vermilion**

## 5. Build the bricks

When the first wash is completely dry, lay a light wash of Vermilion mixed with Raw Sienna over the bricks, working around the cream mortar. Add Naples Yellow to the mixture for the bricks in brighter light. To glaze on the darker shadow, use mostly Burnt Sienna with touches of Cadmium Red Deep or Ultramarine Blue.

**Vermilion**
**+ Raw Sienna**

**Vermilion**
**+ Raw Sienna**
**+ Naples Yellow**

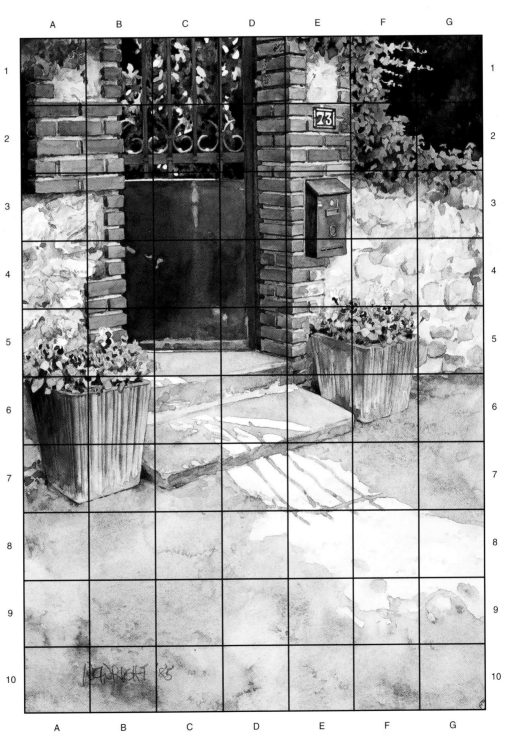

# Put it all together

## 6. Add the blues

When the brick color has dried completely, lay a foundation of Cerulean Blue mixed with Ultramarine over the entire gate and the mailbox. After the first layer has dried, apply a second, stronger coat of blue made of mostly Ultramarine plus some Cerulean and a touch of Burnt Sienna. The details on the mailbox may require another glaze of Ultramarine.

## 7. Paint the pots

Notice how the pots have dirt crusted around their bottom edges? It'll be easier to paint the pots upside down, so turn your board around. Apply relatively little water and then lay in one of the darker sand colors mixed earlier. Still working wet-into-wet, transition softly into a mixture of Phthalo Green, Cerulean Blue and a touch of Vermilion. Let these washes dry thoroughly before moving the board.

## 8. Put in the steps and walkway

In addition to the sand colors you mixed earlier, mix up other large batches of light gray (Cerulean and Vermilion), dark gray (Ultramarine and Burnt Sienna) and a combination of the two. Also moisten any palette colors you think you might use, such as Raw Sienna, Opera or Alizarin. Then wet the entire area of cast shadows, including the pattern from the gate. Begin dropping in the colors you've mixed, roughly following my original but interpreting this area in your own way. Make only one pass here, except for glazing on the shadowed sides of the steps.

## 9. Move into yellows

Next, warm up some of your sand-colored mixtures with more yellows and siennas. Then use these colors, as well as the grays, to put in the individual stones with a lot of variation in color. Glaze as needed to get the rough stone texture. While you have these warm yellows and golds on your palette, glaze warm gold over the mortar in the bricks where needed. Also apply a foundation of bright yellow over the potted plants. Use a mixture of Cadmium Lemon with a little Cerulean to wash in the bright green ivy beyond the wall.

**Cream mixes + gray mixes + Raw Sienna**

## 10. Fill in the flowers

Working one small area at a time, put in the flowers, using your favorite colors and mixtures from previous projects. Use lighter and darker versions of cool green for the leaves.

## 11. Complete the greenery

Mix up a variety of greens before you get started, such as Cerulean Blue mixed with Cadmium Lemon, Aureolin mixed with Ultramarine, Hookers Green mixed with Ultramarine, and Prussian Blue mixed with Cadmium Yellow Deep. You will also need a large quantity of medium blue-green made by combining Aureolin, Ultramarine and Oxide of Chromium. Apply this color to the ivy on either side of the bricks. While this wash is drying, use this same color to define the grooved texture on the flower pots. Then, applying one layer at a time, build up the greenery beyond the gate with the various dark green mixes. Remember to work around the white- and lime-colored leaves. Using one of the darker greens, paint negatively to define the shapes of the ivy leaves.

**Aureolin
+ Ultramarine
+ Oxide of Chromium**

## 12. Finish with the distant background

To layer on this very dark corner area, start with a base color of Ultramarine Blue and Burnt Sienna. With each successive layer, change it slightly by adding Phthalo Violet, then Hookers Green, then Burnt Sienna. Allow parts of the previous layers to show through each new layer. You may want to use this mix for a few dark accents elsewhere, such as behind the gate and in the flowers and ivy.

**Detail**

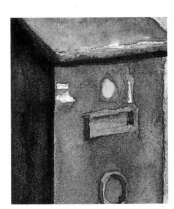

**Detail**

**Detail**

*Gate at #73*, watercolor, 14 x 10" (36 x 26cm) by William C. Wright ©

95

# What artists want!

## If you liked this book you'll love these other titles written specially for you.

### Artist's Projects You Can Paint

Each of the 10 thrilling step-by-step projects in these books gives you a list of materials needed, and initial drawing so you can get started straightaway. Dozens of individual color swatches will show you how to achieve each special mix. Clear captions for every stage in the painting process make this a fun-filled painting adventure.

- **10 Artist's Projects**
  **FLORAL WATERCOLORS**
  **By Kathy Dunham**
  ISBN: 1-929834-50-0
  Publication date: August 04

- **10 Artist's Projects**
  **SECRET GARDENS**
  **IN WATERCOLOR**
  **By Betty Ganley**
  Publication date: Spring 2005

- **10 Artist's Projects**
  **WATERCOLOR TABLESCAPES**
  **LOOSE & LIGHT**
  **By Barbara Maiser**
  Publication date: Spring 2005

- **10 Artist's Projects**
  **MOUNTAIN SPLENDOR IN OIL**
  **By Betty J. Billups**
  Publication date: Spring 2005

- **10 Artist's Projects**
  **LANDSCAPE STYLES**
  **IN MIXED MEDIA**
  **By Robert Jennings**
  Publication date:  Spring 2005

### Art Maps

Use the 15 Art Maps in each book to get you started now!

Art Maps take the guesswork out of getting the initial drawing right. There's a color and materials list and there are plenty of tit-bits of supporting information on the classic principles of art so you get a real art lesson with each project.

- **15 Art Maps**
  **HOW TO PAINT WATERCOLORS**
  **THAT SHINE!**
  **By William C. Wright**
  ISBN: 1-929834-47-0
  Publication date: November 04

- **15 Art Maps**
  **HOW TO PAINT WATERCOLORS**
  **FILLED WITH BRIGHT COLOR**
  **By Dona Abbott**
  ISBN: 1-929834-48-9
  Publication date: October 04

- **15 Art Maps**
  **HOW TO PAINT EXPRESSIVE**
  **LANDSCAPES IN ACRYLIC**
  **By Jerry Smith**
  ISBN: 1-929834-49-7
  Publication date: December 04

### How Did You Paint That?

Take the cure for stale painting with 100 inspirational paintings in each theme-based book. Each artist tells how they painted all these different subjects. 100 fascinating insights in every book will give you new motivation and ideas and open your eyes to the variety of styles and effects possible in all mediums.

- **100 ways to paint**
  **STILL LIFE & FLORALS**
  **VOLUME 1**
  ISBN: 1-929834-39-X
  Publication date: February 04

- **100 ways to paint**
  **PEOPLE & FIGURES**
  **VOLUME 1**
  ISBN: 1-929834-40-3
  Publication date: April 04

- **100 ways to paint**
  **LANDSCAPES**
  **VOLUME 1**
  ISBN: 1-929834-41-1
  Publication date: June 04

- **100 ways to paint**
  **FLOWERS & GARDENS**
  **VOLUME 1**
  ISBN: 1-929834-44-6
  Publication date: August 04

- **100 ways to paint**
  **SEASCAPES, RIVERS & LAKES**
  **VOLUME 1**
  ISBN: 1-929834-45-4
  Publication date: October 04

- **100 ways to paint**
  **FAVORITE SUBJECTS**
  **VOLUME 1**
  ISBN: 1-929834-46-2
  Publication date: December 04

# How to order these books

**These titles are available through major art stores and leading bookstores.**

**Distributed to the trade and art markets in North America by**

F&W Publications, Inc.,
4700 East Galbraith Road
Cincinnati, Ohio, 45236
(800) 289-0963

**Or visit: www.artinthemaking.com**